IMPRESSIONS of
EAST ANGLI

Produced by AA Publishing
© Automobile Association Developments Limited 2008
All rights reserved. No part of this publication may be reproduced, stored in
a retrieval system, or transmitted in any form or by any means – electronic,
photocopying, recording or otherwise – unless the written permission of the
publishers has been obtained beforehand.

Published by AA Publishing (a trading name of Automobile Association
Developments Limited, whose registered office is Fanum House, Basing View,
Basingstoke, Hampshire RG21 4EA; registered number 1878835)

ISBN: 978-0-7495-5892-5

A03828

A CIP catalogue record for this book is available from the British Library.

The contents of this book are believed correct at the time of printing. Nevertheless,
the publishers cannot be held responsible for any errors, omissions or for changes in
the details given in this book or for the consequences of any reliance on the
information provided by the same. This does not affect your statutory rights.

Colour reproduction by KDP, Kingsclere
Printed and bound in Italy by Canale & C SPA

Opposite: Sand dunes and beach at Horsey Gap, Norfolk

IMPRESSIONS *of*
EAST ANGLIA

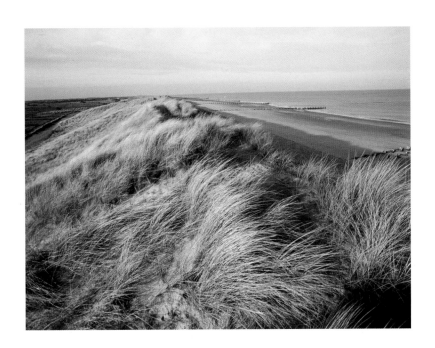

Picture Acknowledgements

The Automobile Association would like to thank the following photographers, companies
and picture libraries for their assistance in the preparation of this book.

Abbreviations for the picture credits are as follows: (AA) AA World Travel Library

AA/T Mackie; 3 AA/M Birkitt; 5 AA/T Mackie; 7 AA/J Miller; 8 AA/D Forss; 9 AA/M Birkitt; 10 AA/J Miller;
11 AA/T Mackie; 12 AA/S & O Mathews; 13 AA/T Mackie; 14 AA/T Mackie; 15 AA/M Birkitt; 16 AA;
17 AA/T Mackie; 18 AA/T Souter; 19 AA/T Mackie; 20 AA/M Birkitt; 21 AA/T Mackie; 22 AA/M Birkitt;
23 AA/M Birkitt; 24 AA/M Birkitt; P25 AA/ S & O Matthews; 26 AA/M Moody; 27 AA S & O Matthews;
28 AA/A J Hopkins; 29 AA/A Baker; 30 AA/T Mackie; 31 AA/T Mackie; 32 AA/M Birkitt ; 33 AA/M Birkitt;
34 AA/M Moody; 35 AA/M Moody; 36 AA/M Birkitt; 37 AA/R J Edwards; 38 AA/T Mackie; 39 AA/M Birkitt;
40 AA/T Mackie; 41 AA/T Woodcock; 42 AA/M Birkitt; 43 AA/M Moody; 44 AA/T Mackie; 45 AA/M Moody;
46 AA/R Irelnd; 47 AA/T Mackie; 48 AA/T Mackie; 49 AA/T Mackie; 50 AA/T Mackie; 51 AA/ L Whitwam;
52 AA/M Moody; 53 AA/A Baker; 54 AA/T Mackie; 55 AA/T Mackie; 56 AA/M Moody; 57 AA/T Mackie;
58 AA/T Mackie; 59 AA/S & O Mathews; 60 AA/T Mackie; 61 AA/M Moody; 62 AA/T Mackie;
63 AA/ L Whitwam; 64 AA/T Mackie; 65 AA/T Mackie; 66 AA/A Baker; 67 AA/T Mackie; 68 AA/T Souter;
69 AA/T Mackie; 70 AA/M Birkitt; 71 AA/M Birkitt; 72 AA/T Mackie; 73 AA/T Mackie; 74 AA/M Moody;
75 AA/T Mackie; 76 AA/M Moody; 77 AA/M Birkitt; 78 AA/Chris Coe; 79 AA/T Mackie; 80 AA/T Mackie;
81 AA/T Mackie; 82 AA/H Williams; 83 AA/T Mackie; 84 AA/T Mackie; 85 AA/A Baker; 86 AA/T Mackie;
87 AA/T Mackie; 88 AA/T Mackie; 89 AA/M Moody; 90 AA/T Mackie; 91 AA/T Mackie; 92 AA/T Mackie;
93 AA/T Mackie; 94 AA/T Mackie; 95 AA/T Mackie

Every effort has been made to trace the copyright holders, and we apologise in advance for any unintentional omissions
or errors. We would be happy to apply the corrections in any following edition of this publication.

*Opposite: The windmill at Wicken Fen, Cambridgeshire, the last surviving Fenland drainage mill in
Britain's oldest reserve*

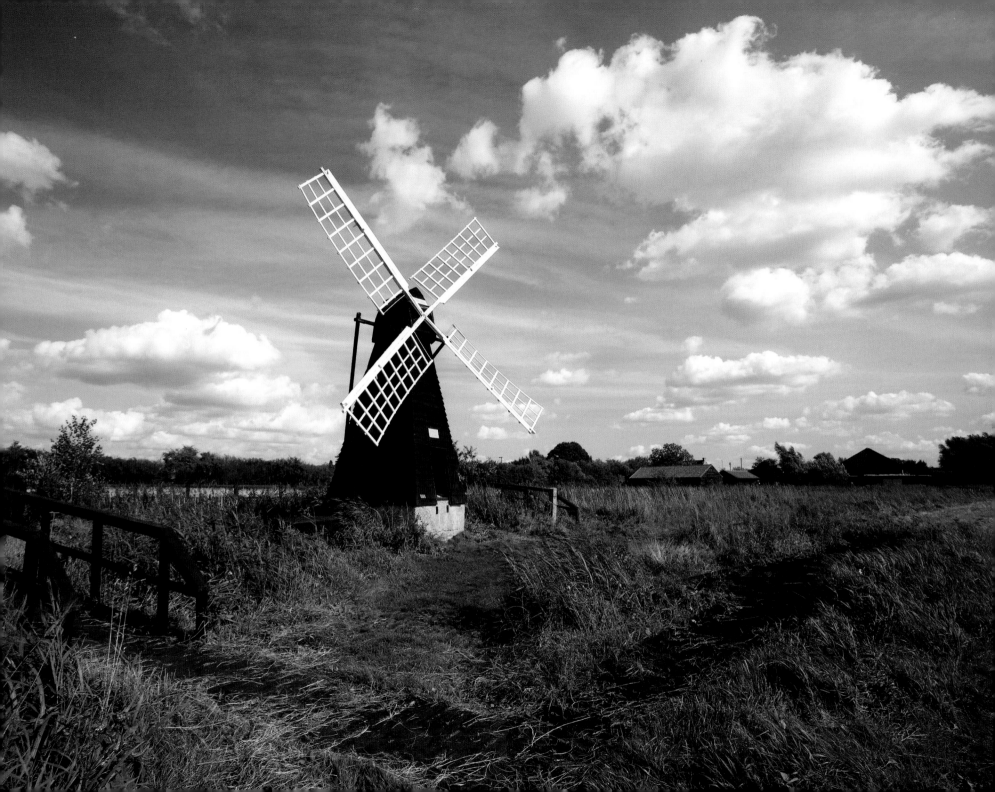

INTRODUCTION

East Anglia is a delightful, secluded corner of England, embracing the predominantly rural and very fertile lands of Norfolk, Suffolk and Cambridgeshire, and the busier, more urbanised counties of Bedfordshire, Hertfordshire and Essex. Combined they present a green, brown and yellow vista of farmlands, more extensive than anywhere else in the British Isles, some rolling over gentle, undulating hills, others disappearing into empty skies of the flat lands of the unique Fens. Elsewhere the intensive agrarian landscape gives way to extensive heathland and forest, spectacular breezy coastlines peppered with estuaries and creeks, attractive little valleys dotted with sleepy villages, and the watery landscape of the Broads, a network of lakes and reed-fringed rivers that provide a superb habitat for wildlife.

North Norfolk is gloriously timeless and unspoilt in parts. Some of the wildest, most exhilarating coastal scenery is to be found here – wonderful windswept sandy beaches and miles of bird-rich salt marsh that draw walkers and bird-spotters in their droves. Inland Norfolk is excellent cycling country, with quiet lanes meandering across a gently rolling landscape, linking picturesque villages and churches. You'll also find some grand houses, notably Royal Sandringham, the splendid Palladian mansion of Holkham Hall, and Blickling Hall, one of England's finest Jacobean houses. There are some traditional seaside resorts, namely Cromer and Great Yarmouth, and Norwich is a distinguished yet lively cathedral city.

Suffolk retains its own distinct identity, its gentle inland scenery and the bracing North Sea coast making ideal holiday destinations. Inland Suffolk has narrow, twisting roads, isolated farms, picture-postcard hamlets, and the classic English villages of Lavenham, Cavendish and Clare, full of appealing timbered and plastered houses, antique shops, teashops, and grand churches built from medieval wool-trade wealth. South, close to the border with Essex, lies Constable country, and famous Flatford Mill. Suffolk's coastline has a nostalgic feel, as well as a curious emptiness. Visit Woodbridge on the Deben river, Orford Castle, the elegant resort of Southwold, and Aldeburgh, famous for its musical festival and regatta.

North Essex has a real East Anglian flavour, with quaint villages, handsome timber-framed houses, and the glorious Stour Valley for peaceful cycling and Constable's famous landscapes. Don't miss Roman Colchester and the beautiful weaving villages in the north east of the county.

Outside and beyond the ancient university city of Cambridge, there are gems to discover in the fenland landscape, characterised by wide horizons interrupted only by an occasional church or the distinctive outline of a solitary windmill. Highlights include Ely Cathedral, one of Britain's most outstanding cathedrals, which dominates the little fenland town and surrounding landscape, Wicken Fen, an undrained fenland that gives an insight into how East Anglia would have looked in the 17th century, and 12th-century Anglesea Abbey at Lode. Parts of Bedfordshire and the Dunstable Downs offer decent walking and remarkable views, otherwise the county's landscape is level and perfect for gentle cycling. There are some first-class family days out such as Woburn Abbey and Whipsnade Zoo, and the gorgeous Luton Hoo, a fine Robert Adam mansion, is worth visiting. Although neighbouring Hertfordshire is built up there are attractive villages to explore, and the county's highlights include Knebworth House, and the Grand Union Canal.

Sunset silhouetting ancient beech trees in Epping Forest, Essex

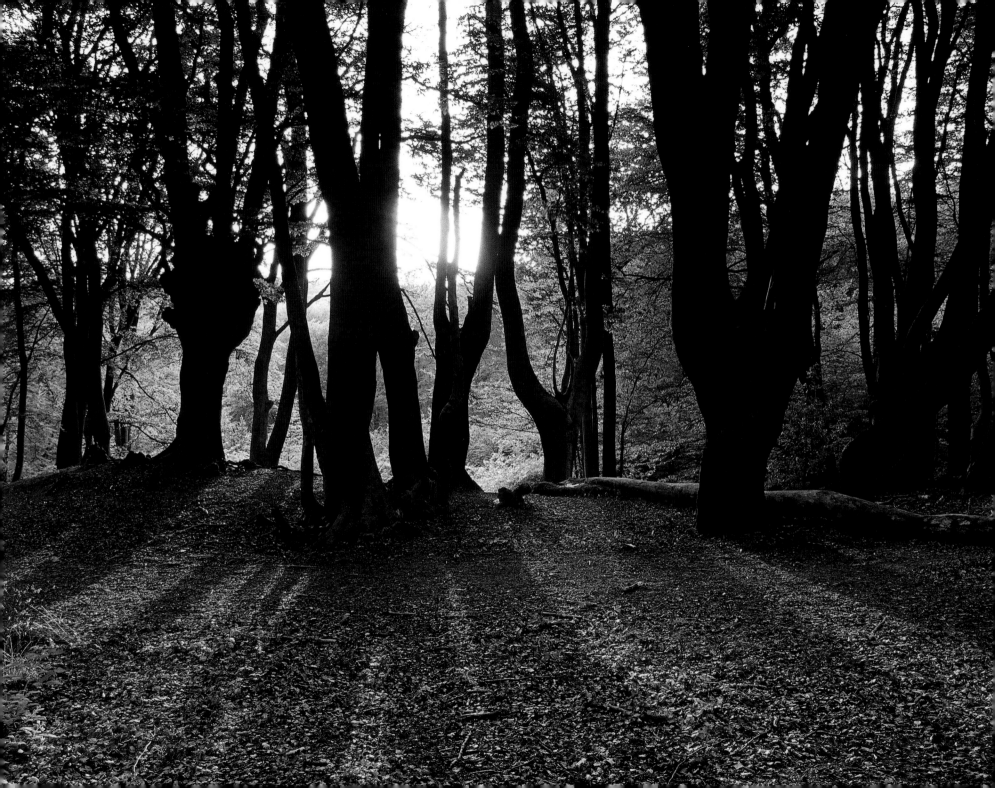

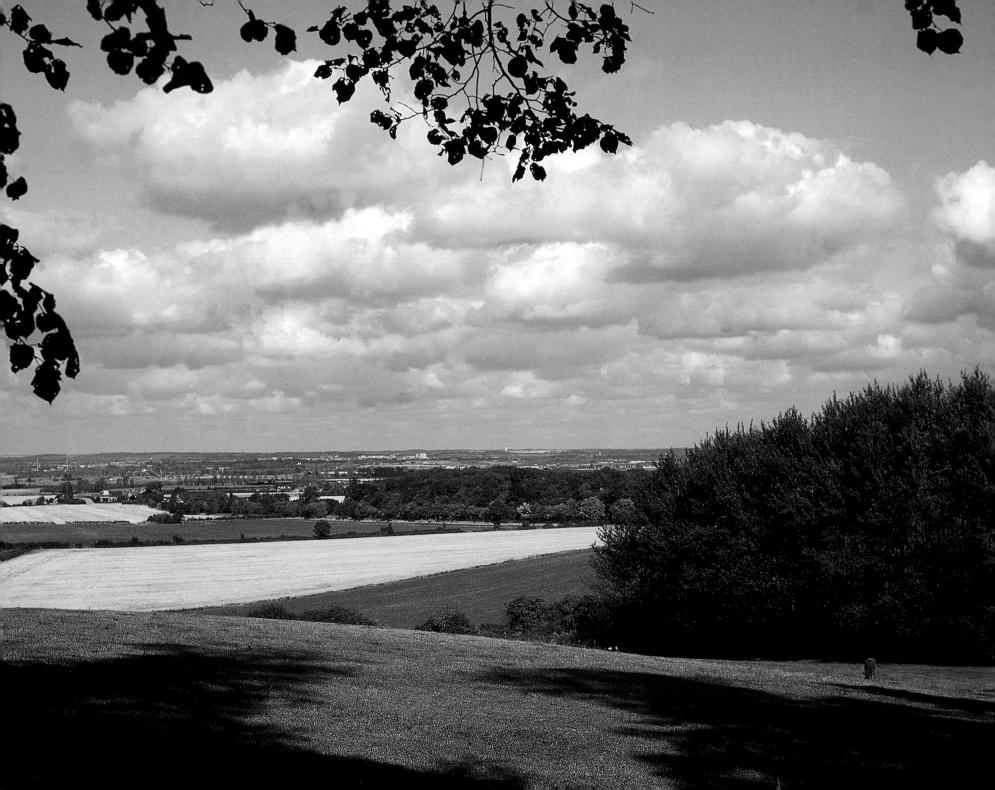

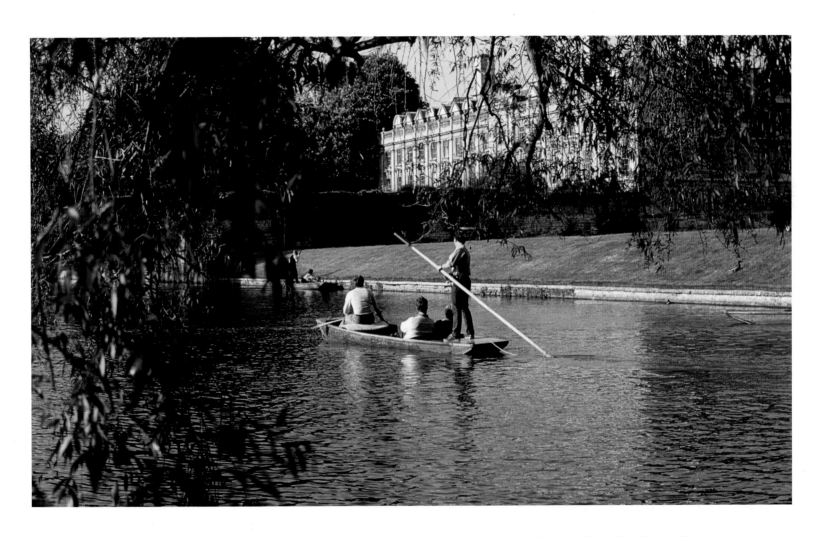

Punting along The Backs offers a different perspective of Cambridge, gliding past famous colleges like Clare College
Opposite: Looking north from Laurel Wood over the wooded, rolling hills close to Ampthill, Bedfordshire

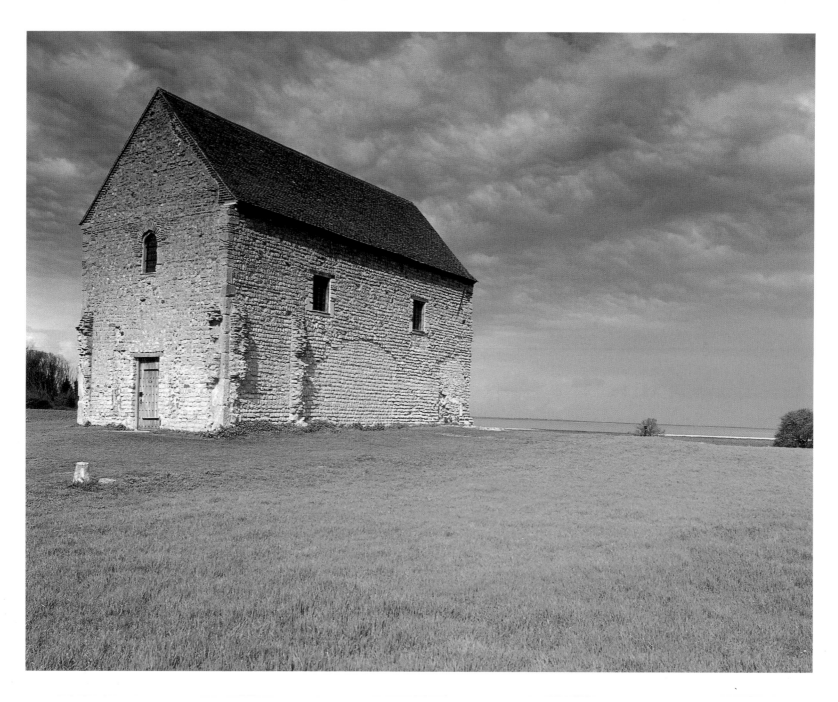

Brooding skies and lonely marshes provide the romantic setting for the 7th-century Chapel of St Peter-on-the-Wall, near Bradwell-on-Sea, Essex

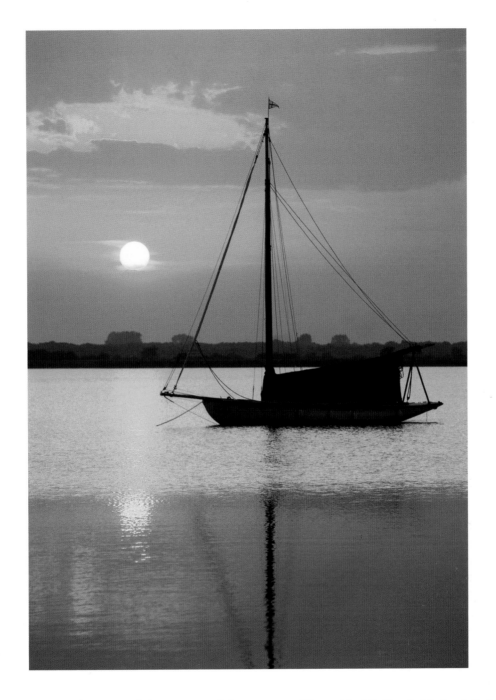

Sailboat bathed in orange light on Horsey Mere at sunset, Horsey, Norfolk Broads National Park

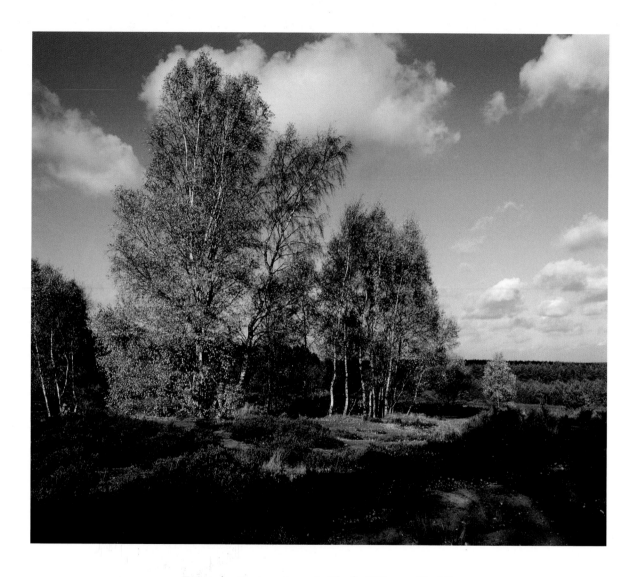

Forest clearing in autumn in Thetford Warren, Norfolk

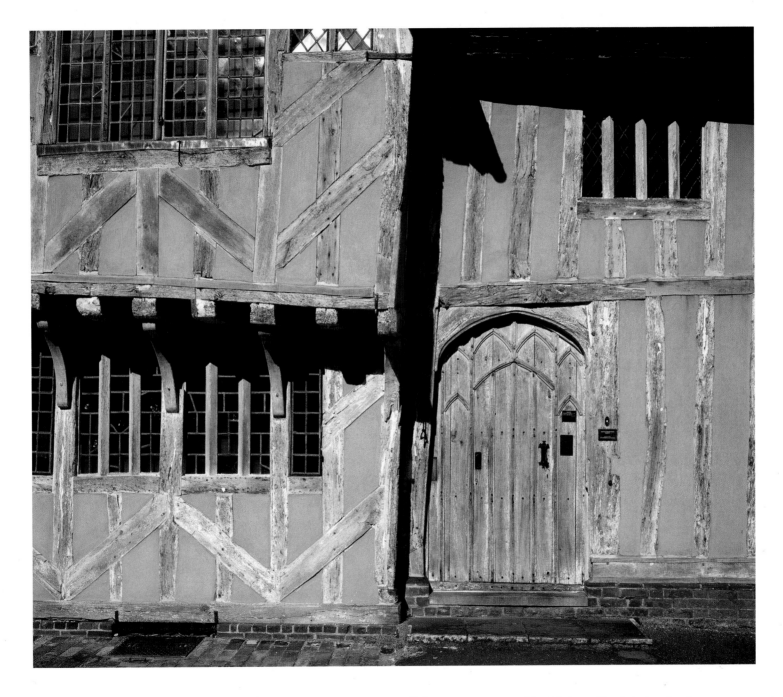

Timberwork on the 14th-century Little Hall at Lavenham, Suffolk, a town incomparably rich in medieval timber-framing

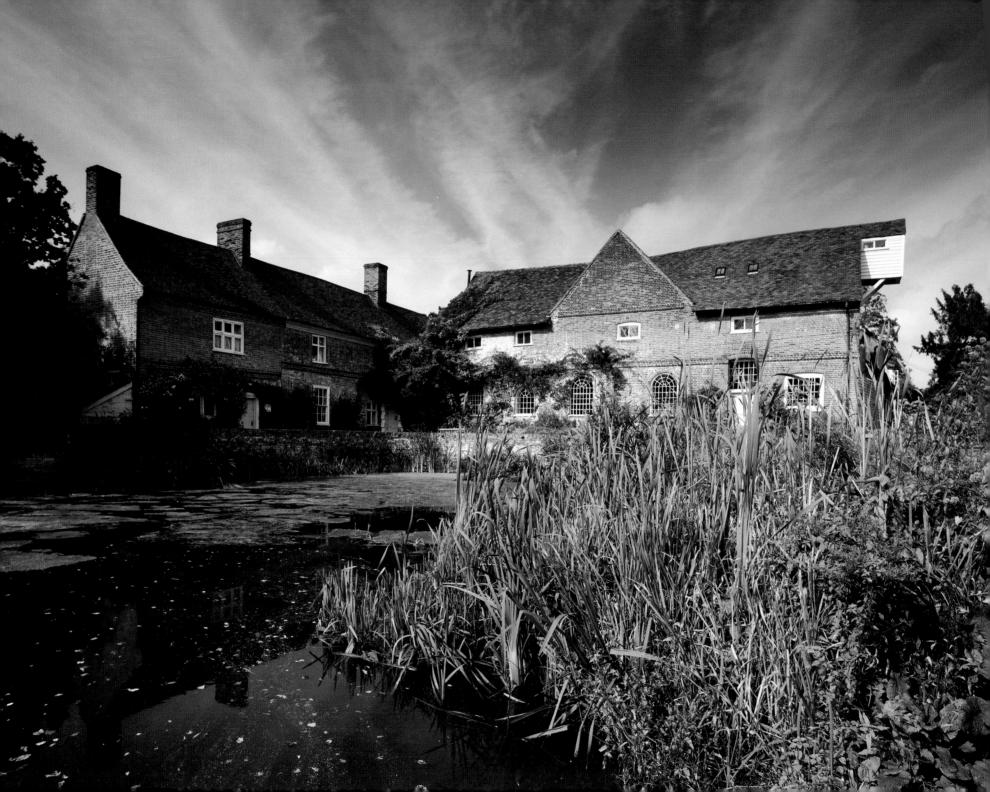

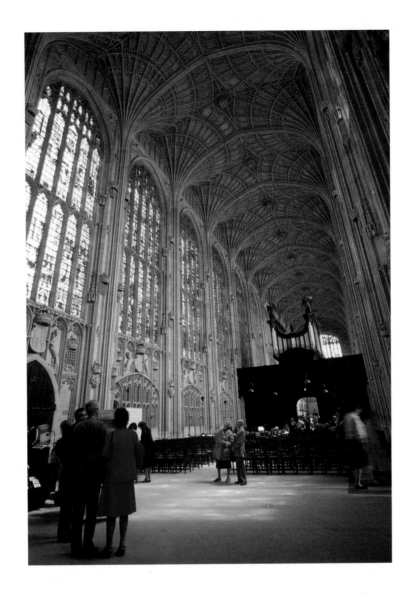

Visitors admire the ornate, fan-vaulted ceiling and Gothic architecture of Kings College Chapel, Cambridge
Opposite: View across the millpond towards Flatford Mill in East Bergholt, Suffolk

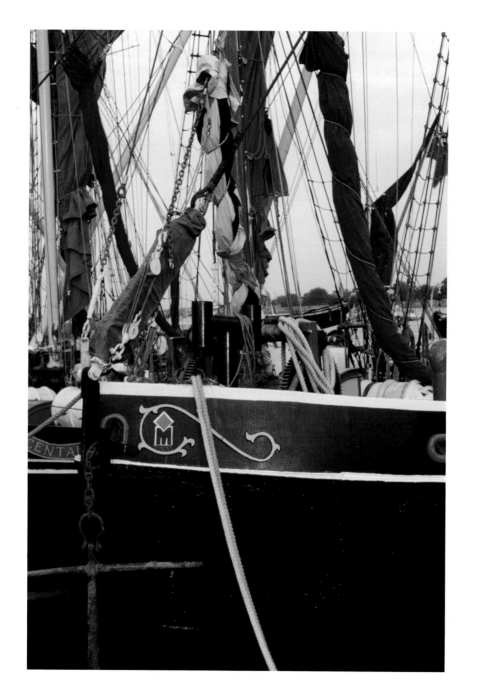

Rigging on a Thames barge at Maldon, Essex

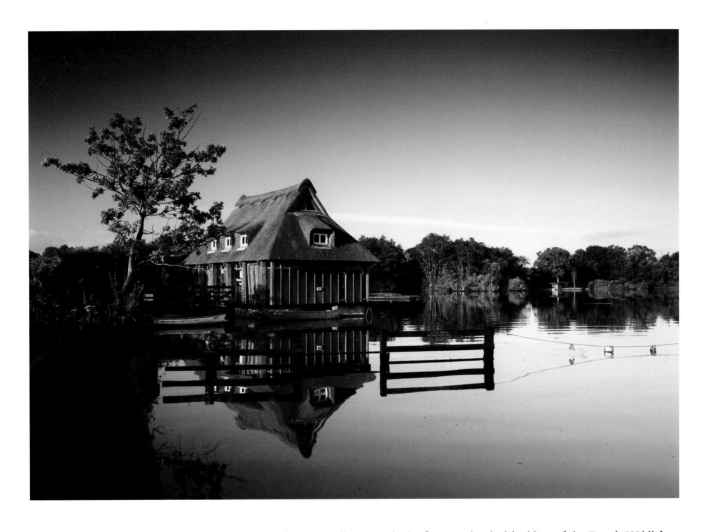

Looking across Ranworth Broad, the largest in the Bure Valley, towards the floating, thatched building of the Broads Wildlife Centre, Norfolk Broads National Park

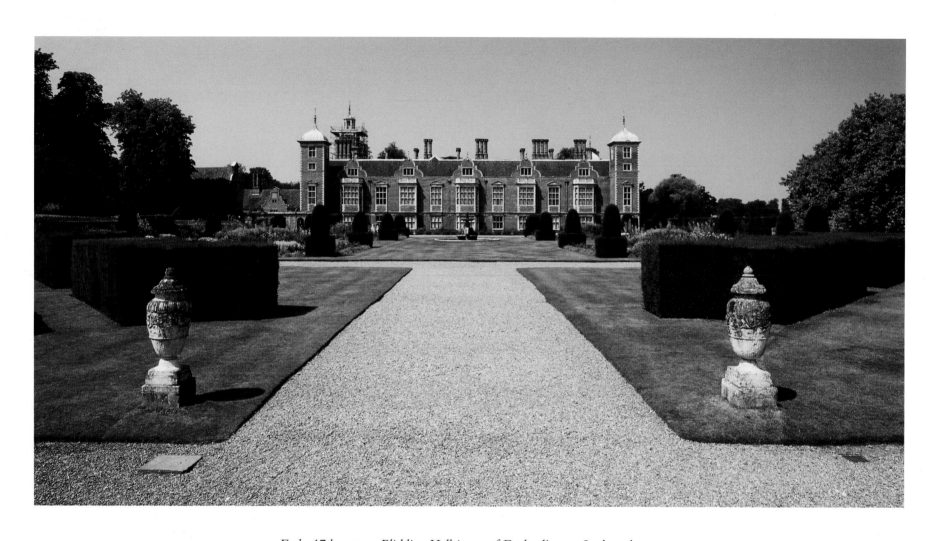

Early 17th-century Blickling Hall is one of England's great Jacobean houses
Opposite: Sunlit evening looking along the Dunwich coast towards Sizewell Power Station, Suffolk

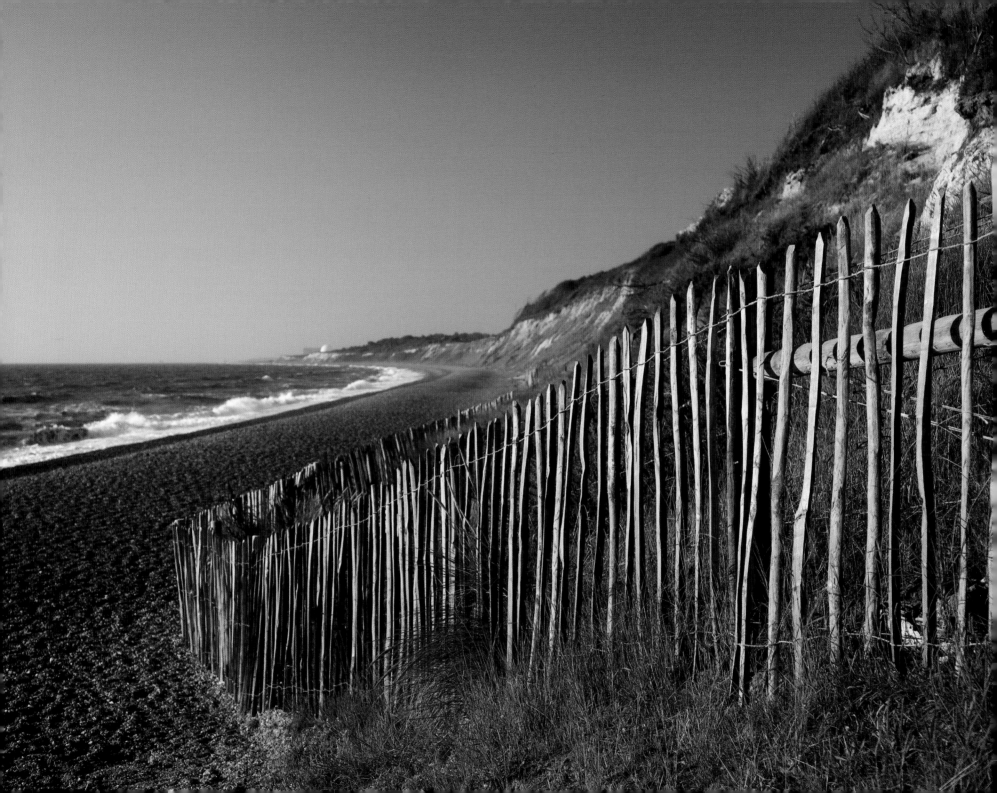

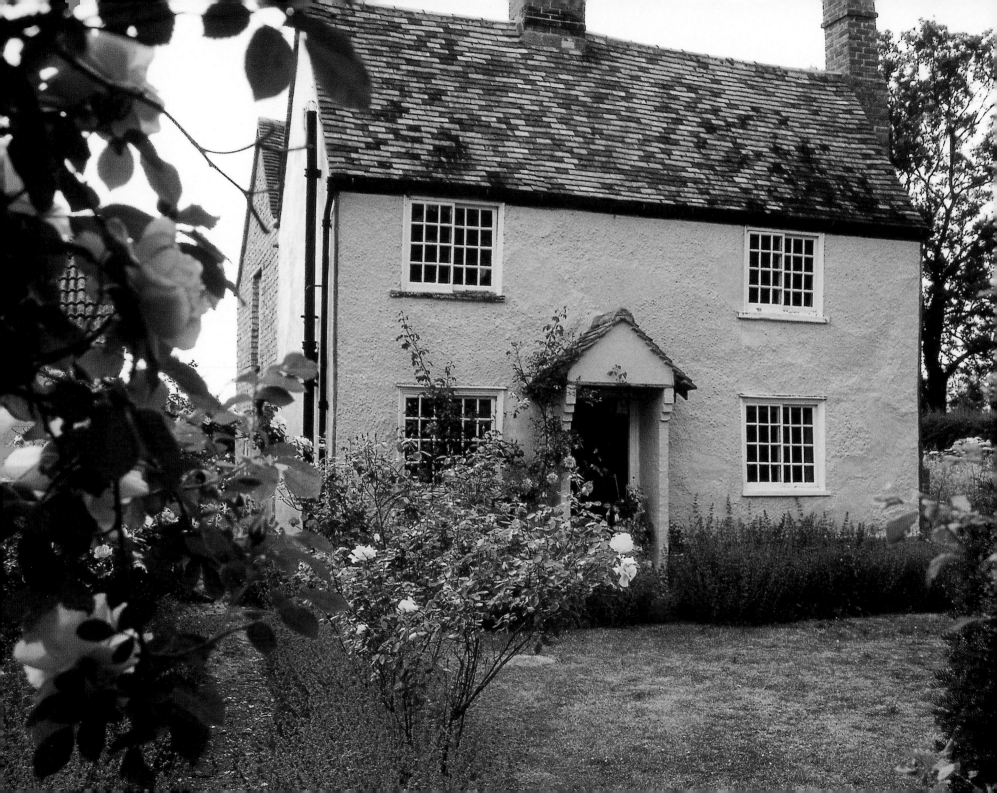

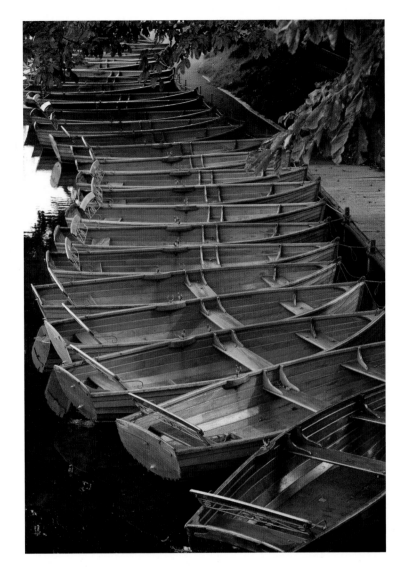

Boats moored along the River Stour in Dedham, Essex
Opposite: A striking, colour-washed cottage fronted by a traditional garden of roses and lavender in Shelton, Bedfordshire

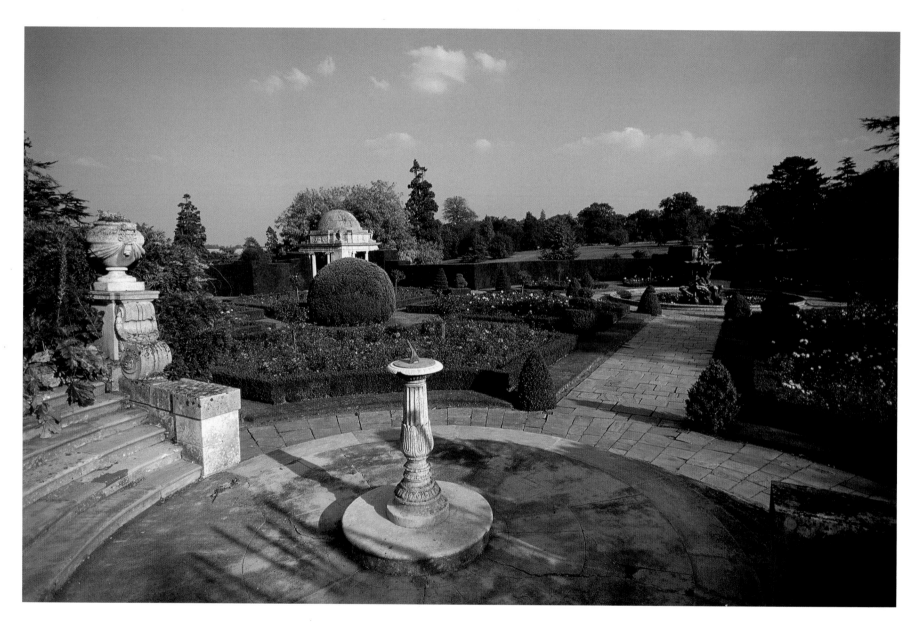

Designed by 'Capability' Brown in the 18th century, the formal Rose Garden and landscaped gardens surround Luton Hoo, a sumptuous Robert Adam mansion housing a fine collection of art treasures

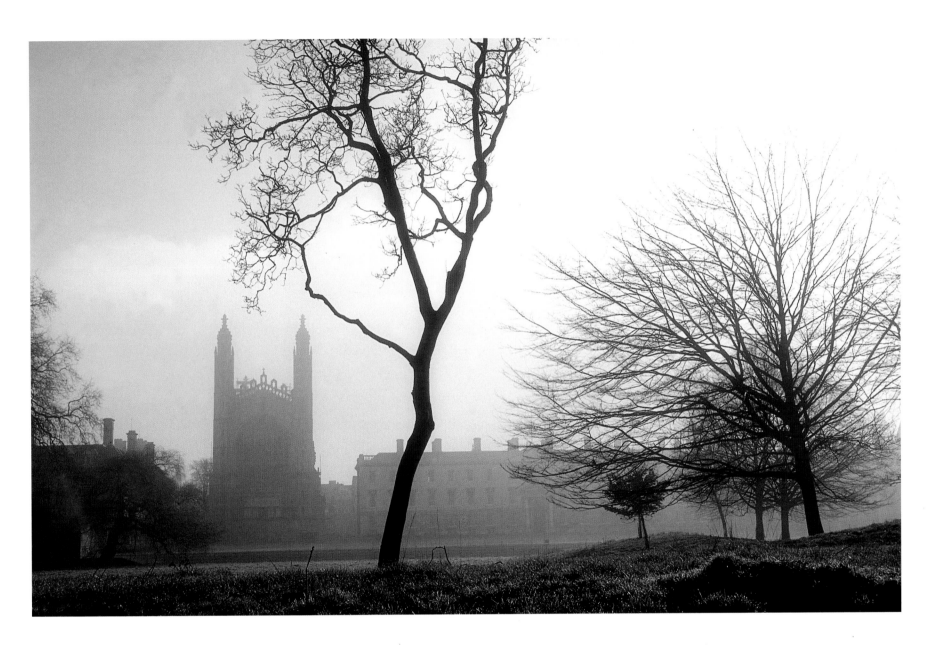

Cambridge's most celebrated building, the 15th-century Kings College Chapel, and The Backs shrouded in early morning mist

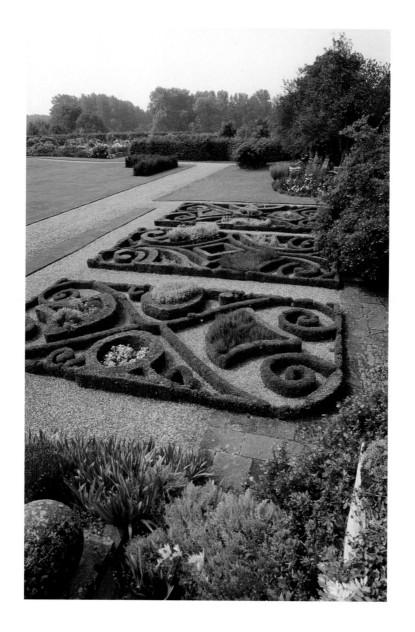

The Knot Garden at Elton Hall, Cambridgeshire, displays the original Edwardian layout of box hedges and herbs

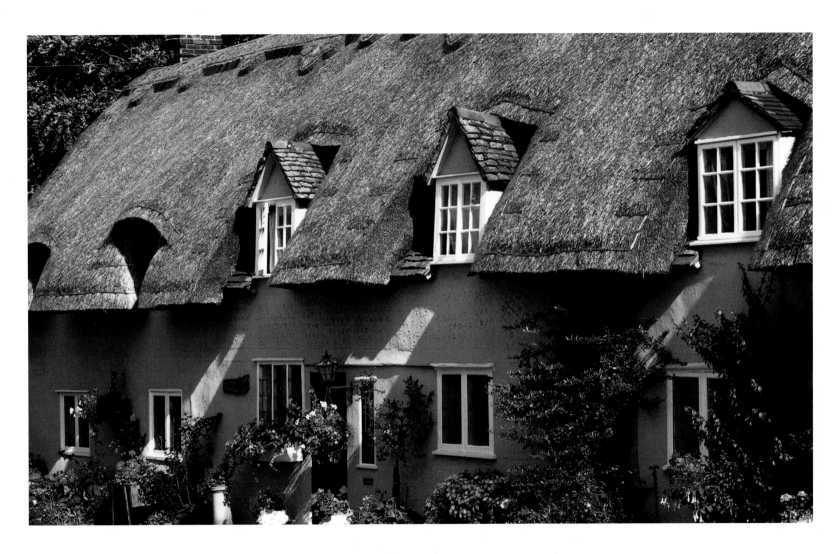

Pink-washed thatched cottages at Pleshey, Essex

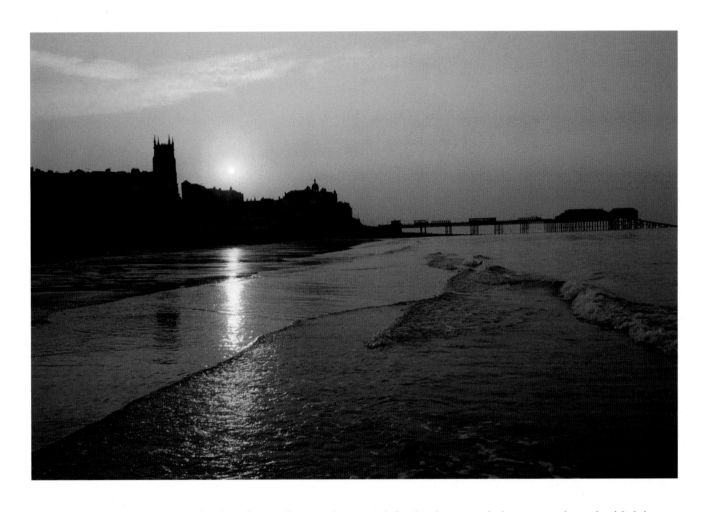

Late evening sun over Cromer beach and pier silhouette the resort's lofty church tower, which once served as a local lighthouse
Opposite: A tranquil scene of boats moored at Tringford Reservoir, Hertfordshire

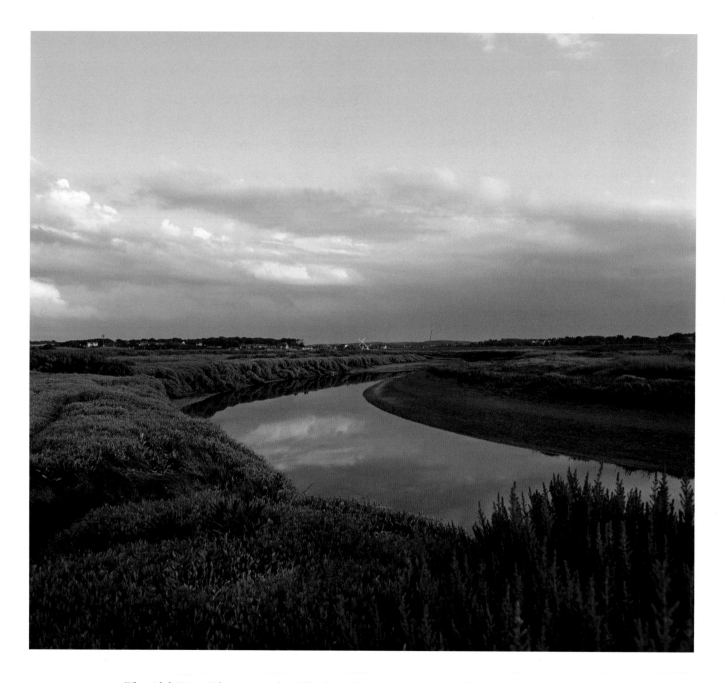

The tidal River Glaven meanders idly through salt marsh towards Cley-next-the-Sea, Norfolk

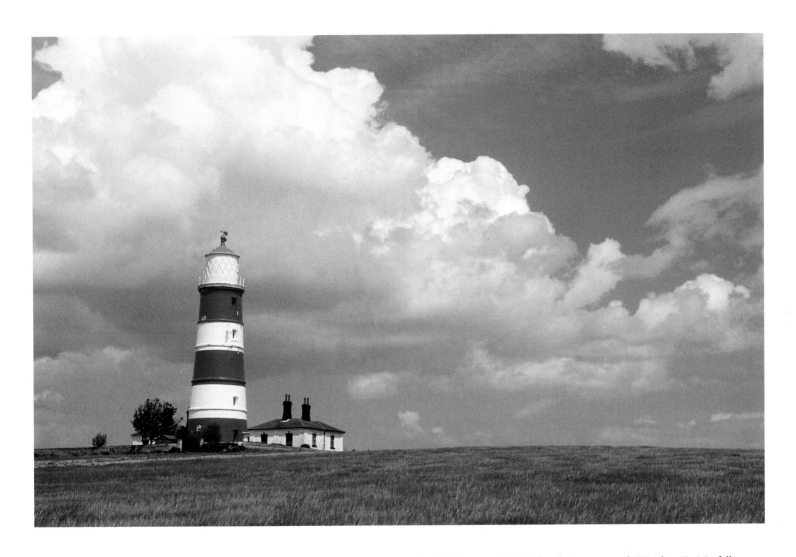

The tall, red-and-white lighthouse dominates the village and surrounding landscape at Happisburgh (pronounced 'Haisboro'), Norfolk

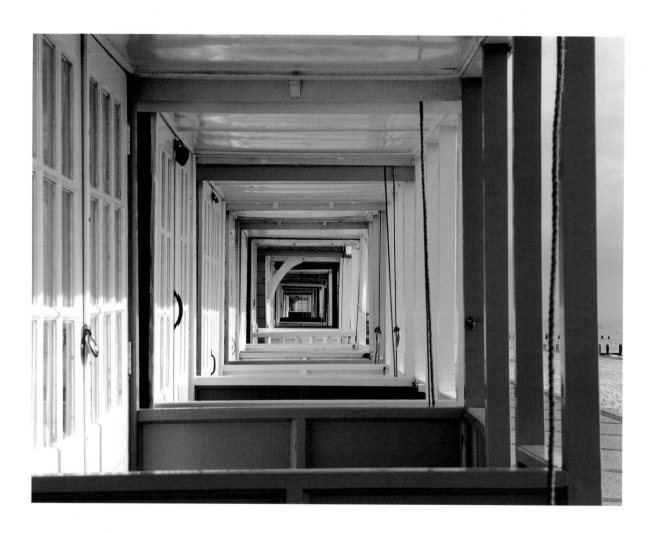

View through colourful bathing huts on the beach at Southwold, Suffolk

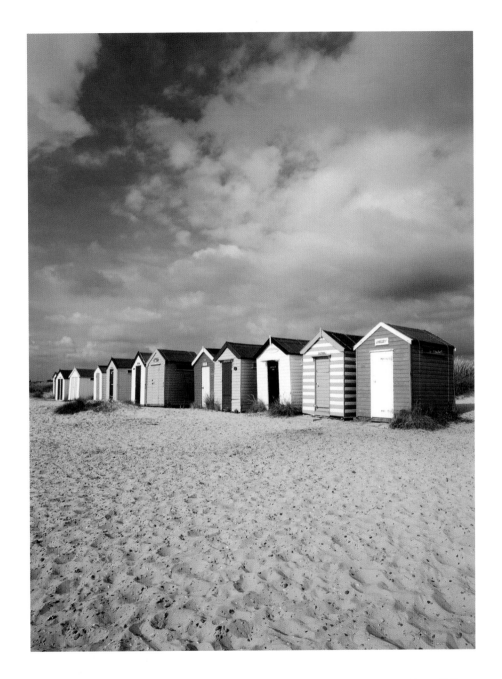

A more conventional view of the bathing huts on the beach at Southwold, Suffolk

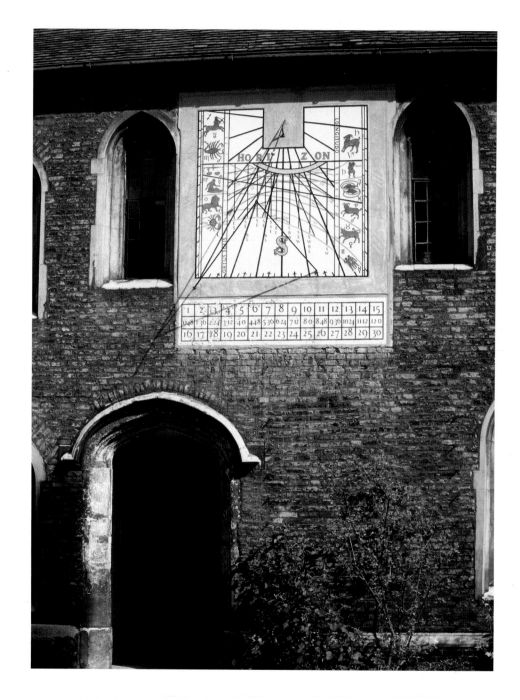

Sundial, dating from 1733, adorning the Front Court, Queens College, Cambridge

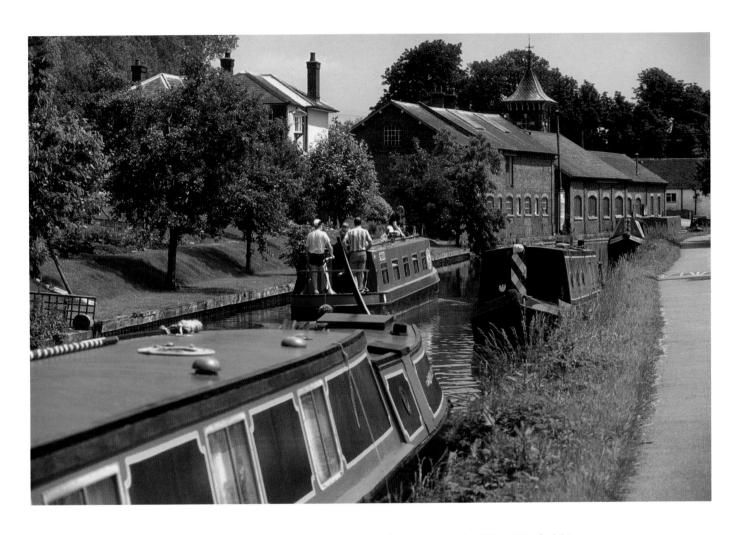

Brightly painted narrow boats on the Grand Union Canal at Tring, Hertfordshire

Blossom on a tree in St Mary's Churchyard, Clothall, Hertfordshire
Opposite: Bluebells carpet the woodland floor in Mill Wood, Hertfordshire

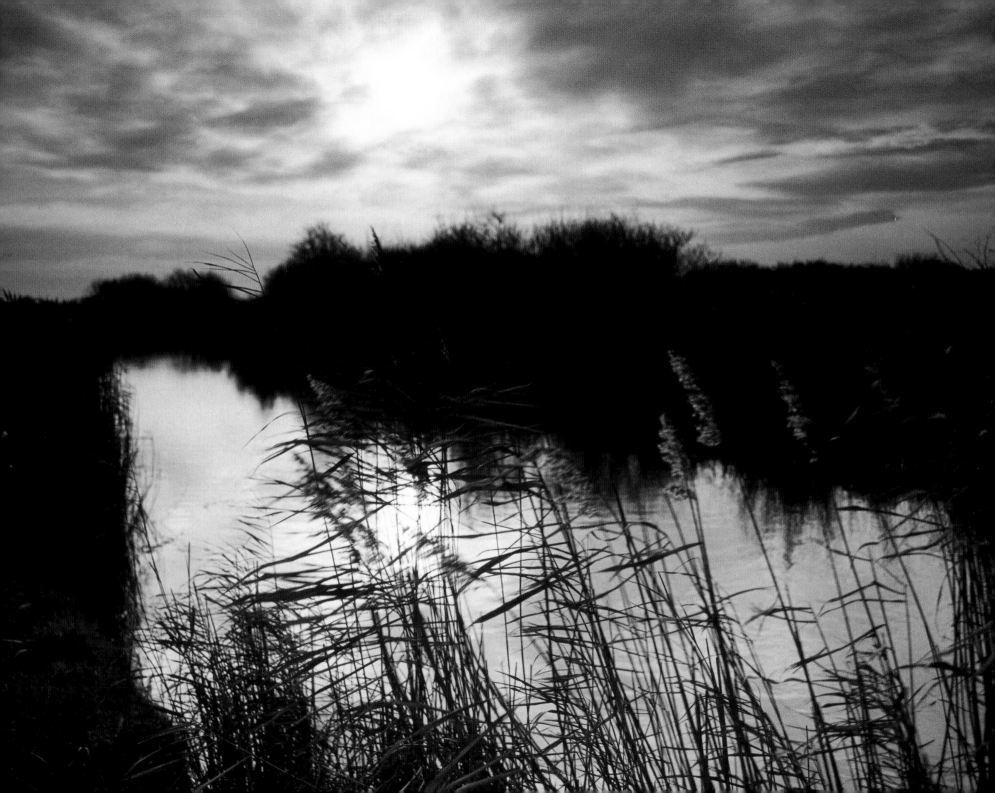

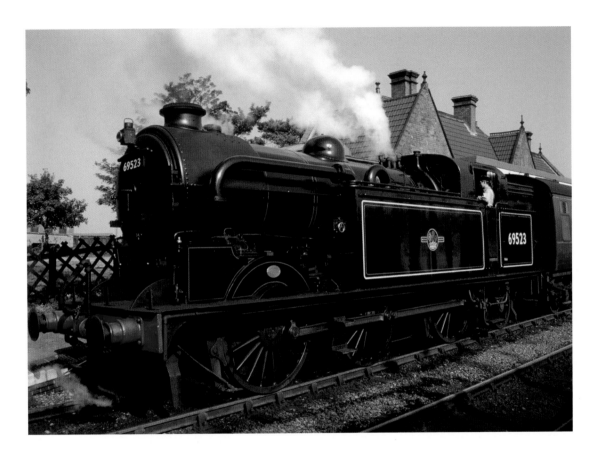

A locomotive steams along the North Norfolk Railway at Weybourne Station, Norfolk
Opposite: Clouds backlit by the setting sun over reed-beds near Horsey Mere, Norfolk Broads National Park

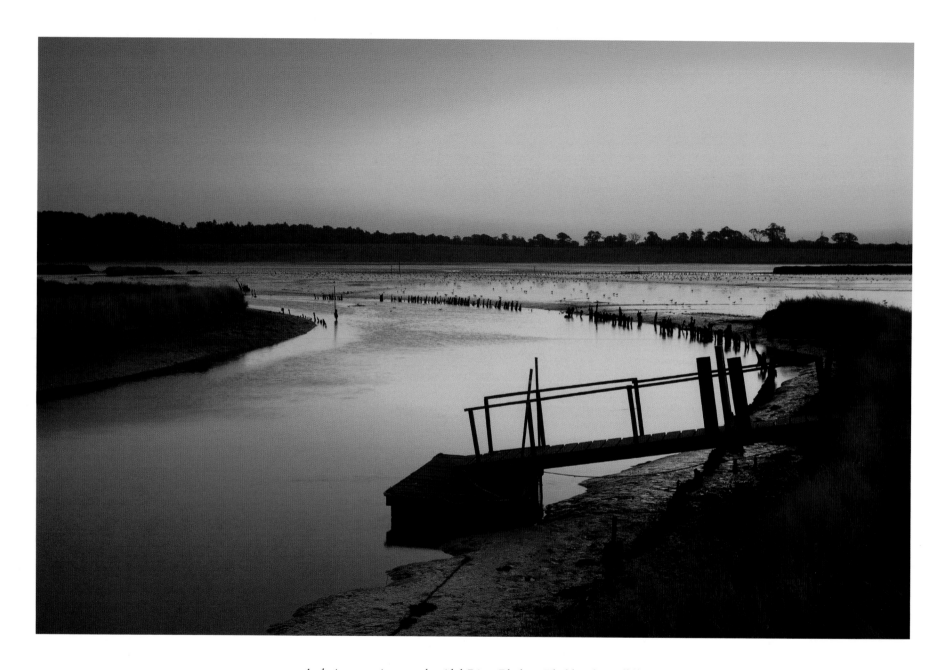

A glorious sunrise over the tidal River Blyth at Blythburgh, Suffolk

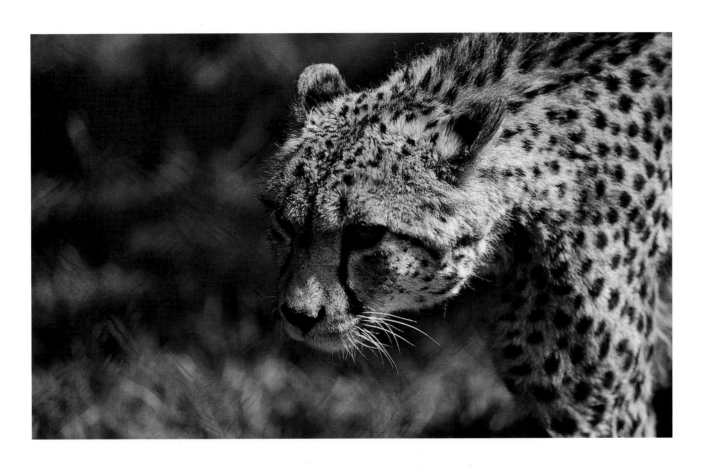

A cheetah at Whipsnade Zoo, Bedfordshire

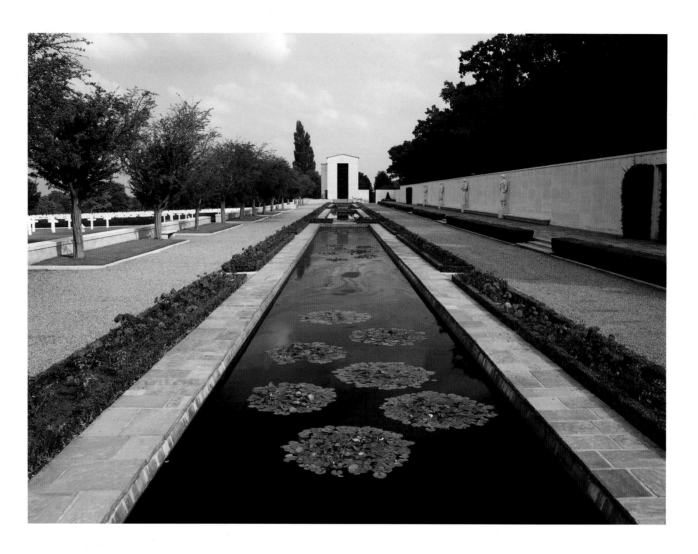

A long ornamental pond at the American Military Cemetery in Madingley, Cambridgeshire

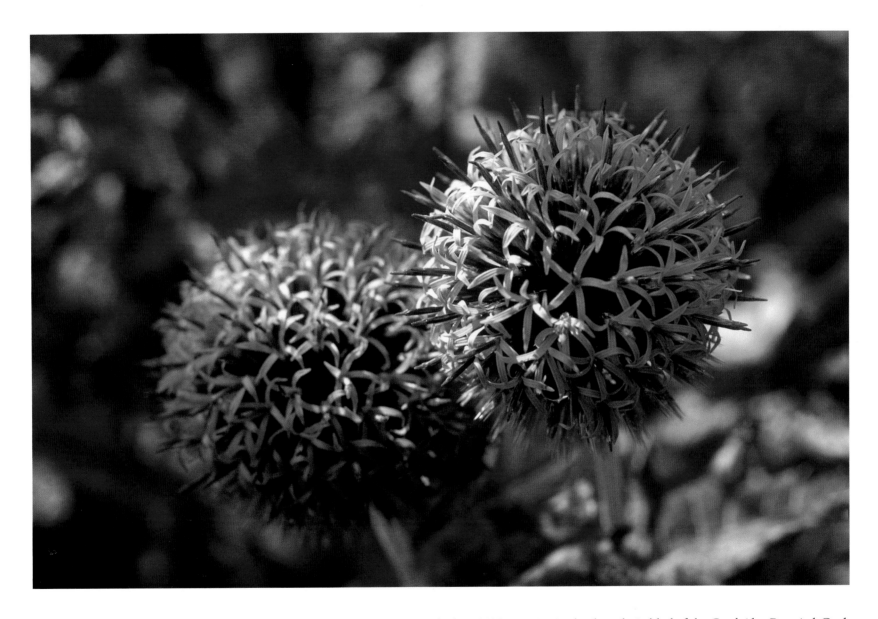

Flowering heads of the purple Globe Thistle, introduced from Eastern Europe in the late 1500s, growing in the chronological bed of the Cambridge Botanical Gardens

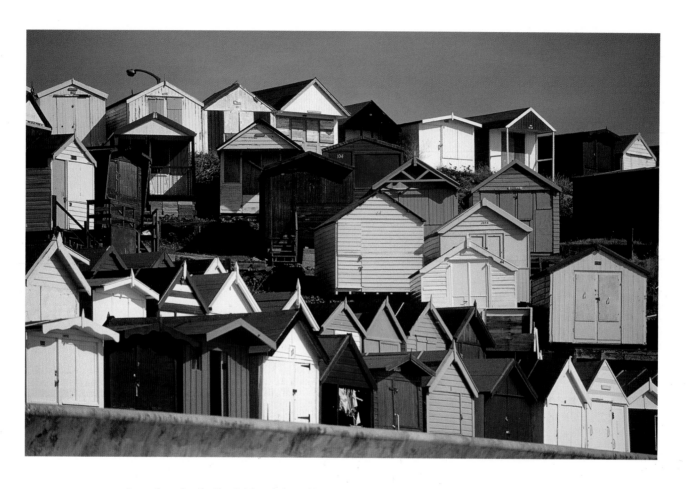

A patchwork of colourful beach huts line the promenade at Walton-on-the-Naze, Essex

Rolling fields of oil seed rape add a splash of colour to the landscape around St Mary's Church, Clothall, Hertfordshire

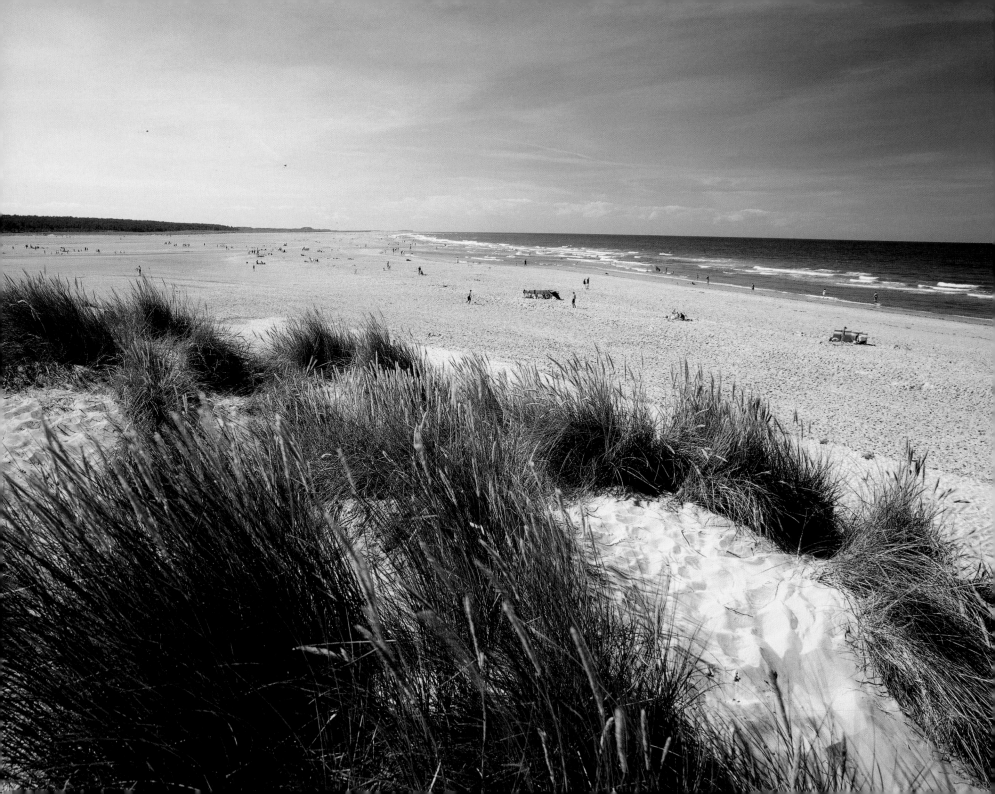

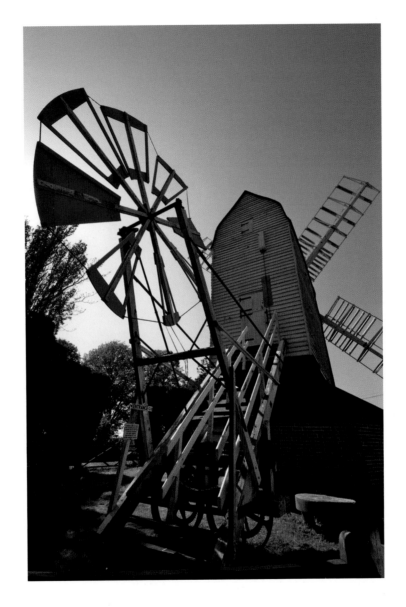

The restored 19th-century Cromer Windmill, Hertfordshire
Opposite: The vast beach at Holkham Bay, backed by dunes and pines, forms part of the impressive Holkham Estate, Norfolk

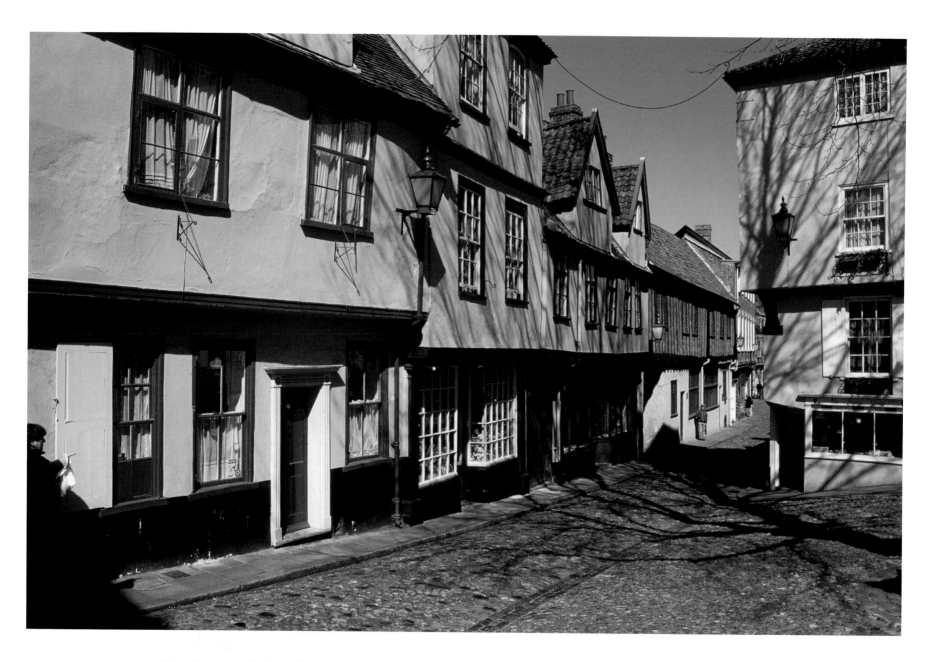

The old quarter of Elm Hill in Norwich, Norfolk, retains its cobbled streets, shady trees and quaint, colour-washed houses

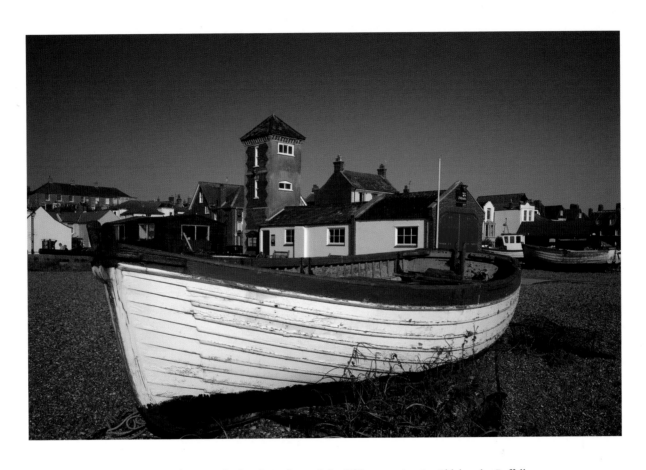

A rowing boat on the beach in front of the lifeboat station in Aldeburgh, Suffolk

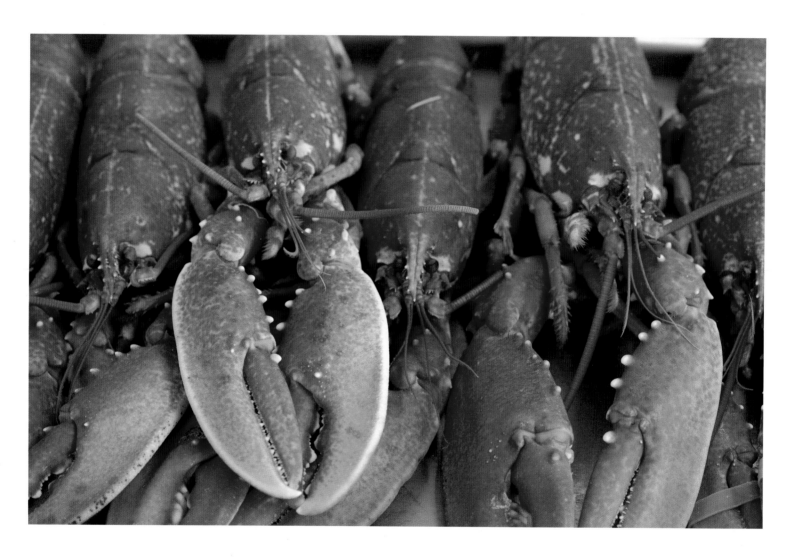

A line of lobsters in a pot at Aldeburgh, Suffolk

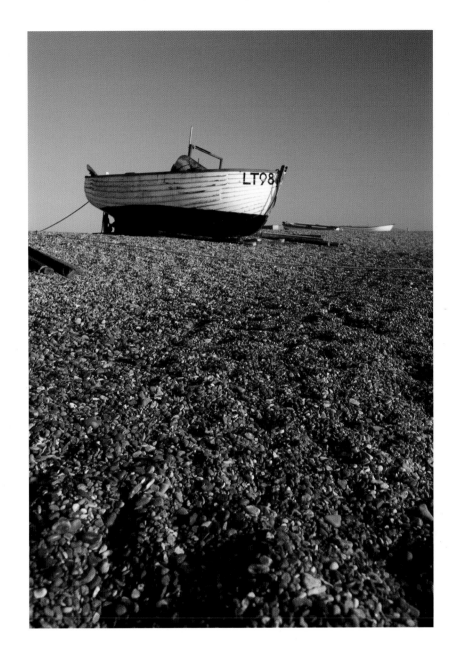

A fishing boat drawn up on the shingle bank at Dunwich beach, Suffolk

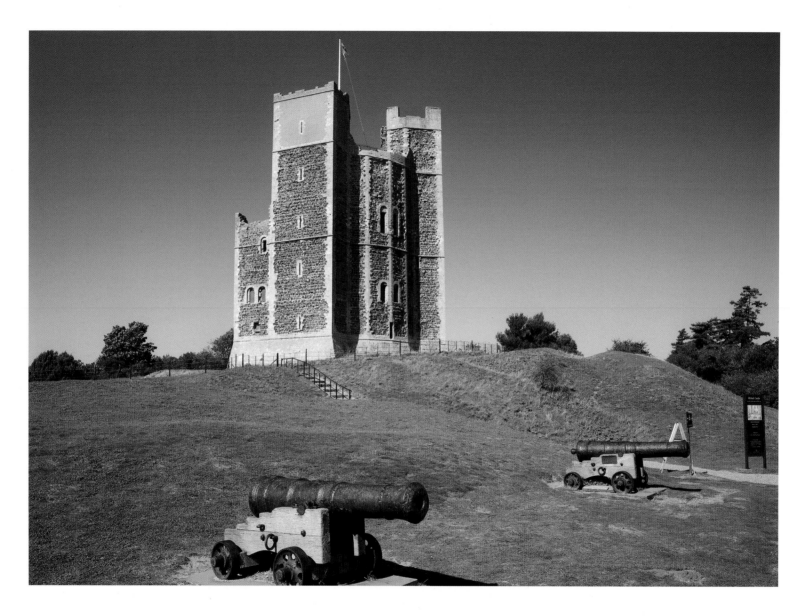

Orford Castle, Suffolk, built in the 12th-century by King Henry II as part of a network of coastal defences, affords magnificent views over Orford Ness from its impressive keep

A fine example of 18th-century decorative plasterwork – pargeting – in Saffron Walden, Essex

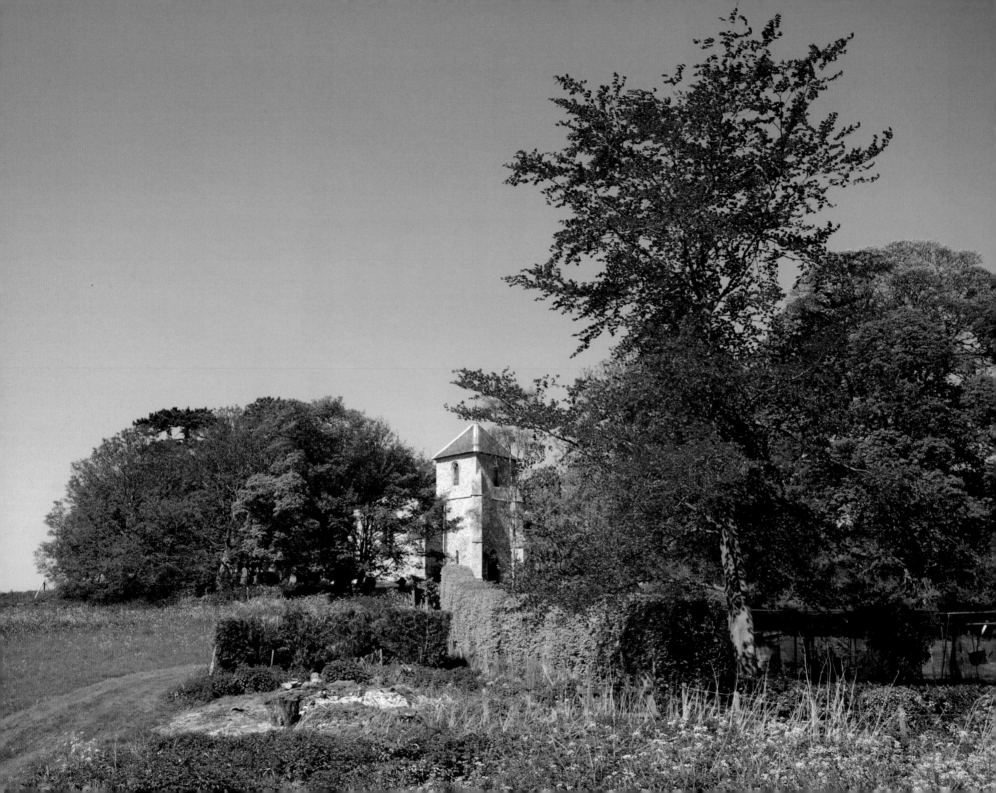

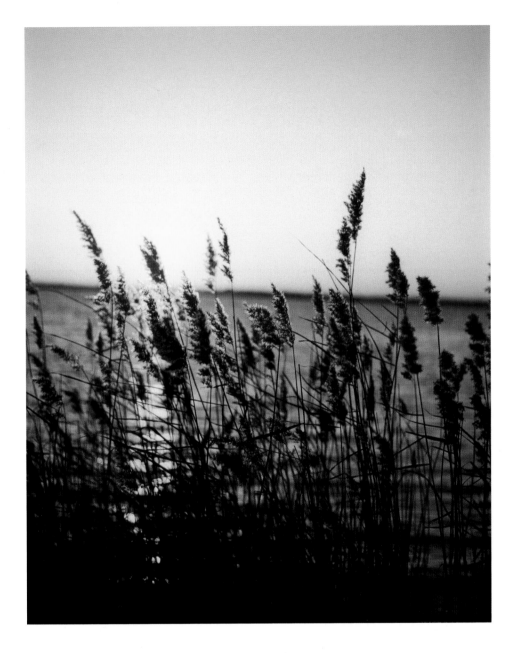

Golden sunset through reeds at Horsey Mere, Norfolk Broads National Park
Opposite: The bucolic pastoral scene at St Mary's Church in Clothall, Hertfordshire

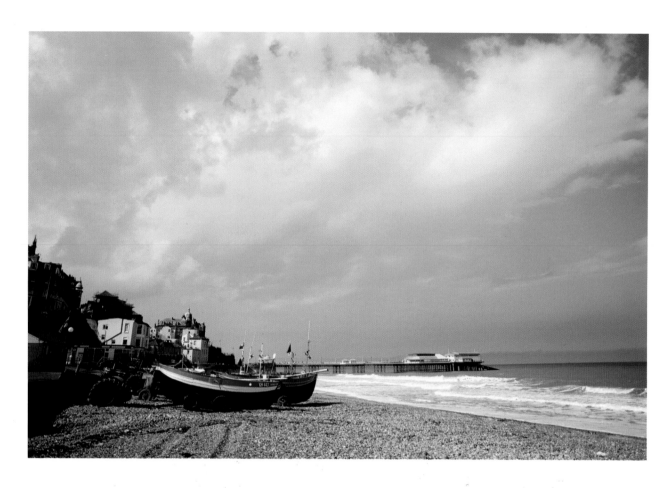

View across the Victorian seafront towards the pier at Cromer, Norfolk

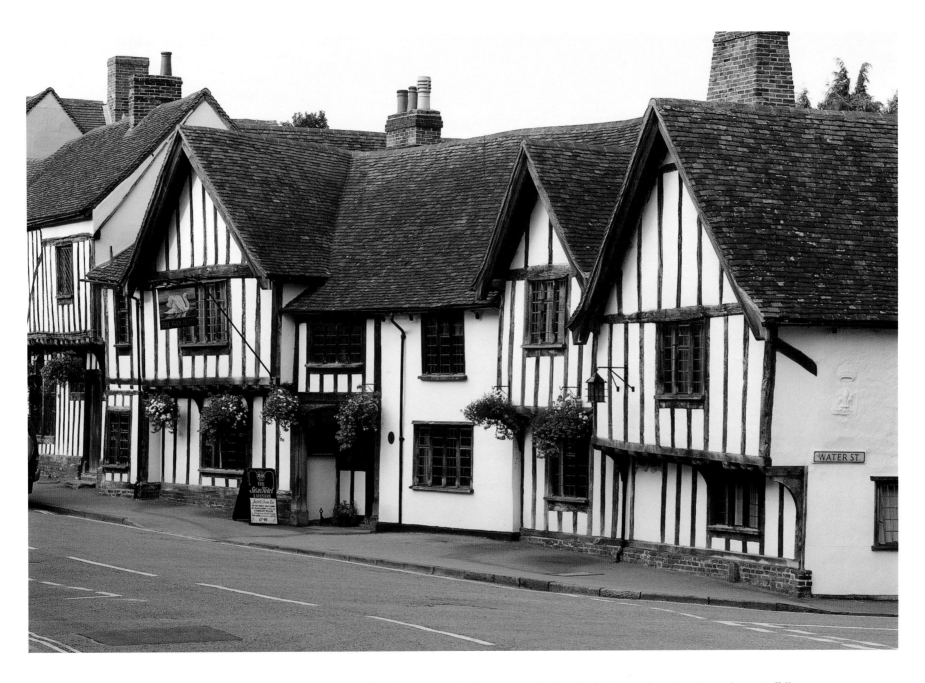

Fine medieval houses like the 15th-century timbered Swan Hotel reflect the wealth brought by the wool trade to Lavenham, Suffolk

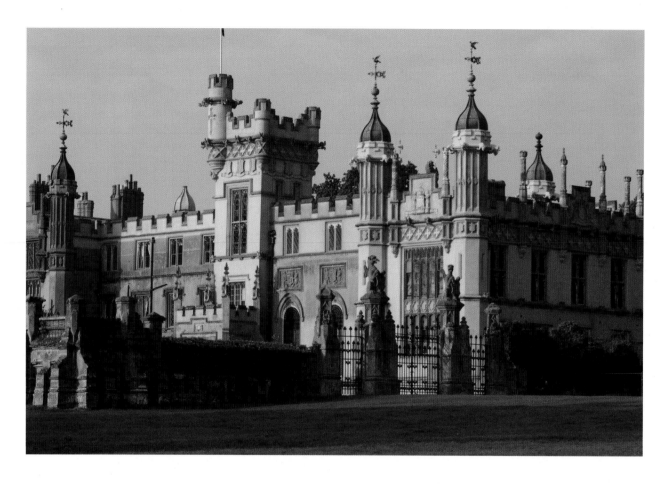

Home of the Lytton family since 1490, the Gothic exterior of Knebworth House, Hertfordshire, is a Victorian confection built by novelist and statesman Sir Edward Bulwer-Lytton
Opposite: Curious goat in Thetford Forest at Breckland, Norfolk

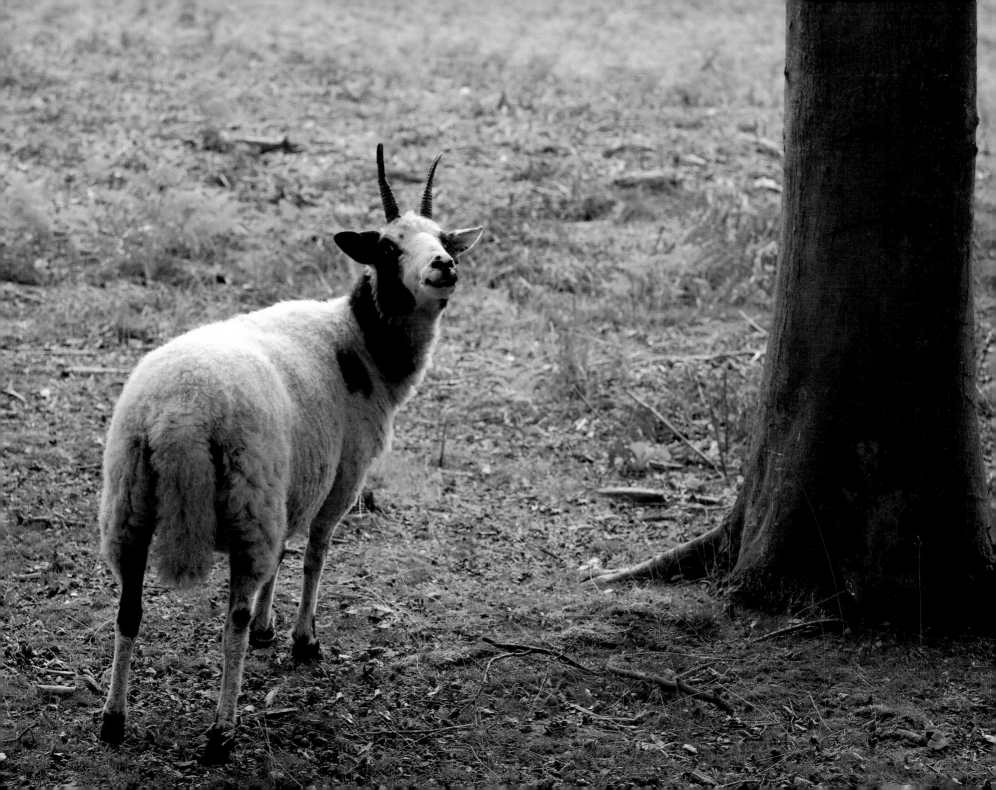

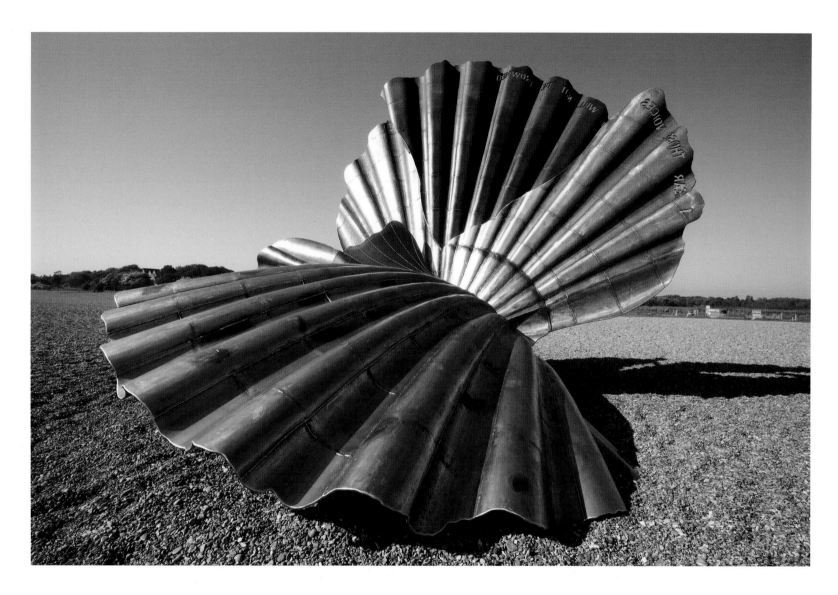

Scallop sculpture on the shingle beach at Aldeburgh, Suffolk

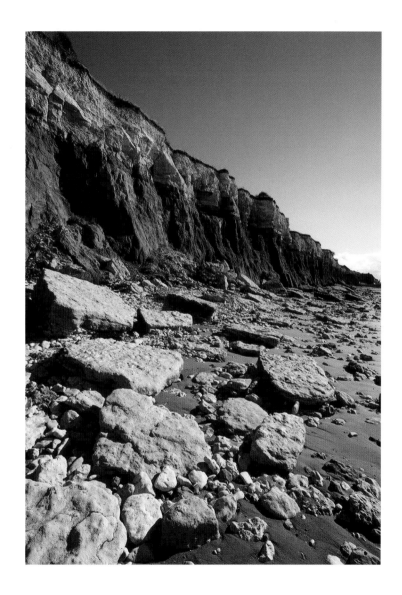

The famous striped cliffs rise 90ft above the beach at Hunstanton, Norfolk

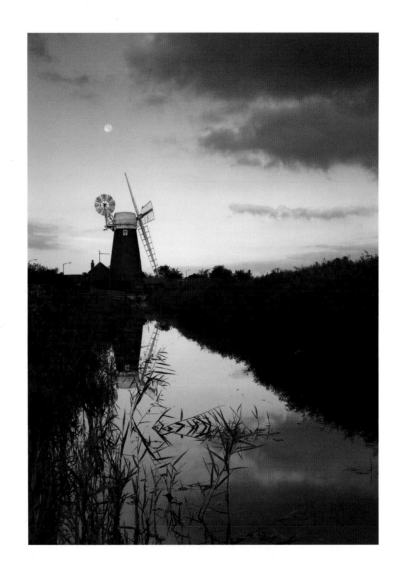

Looking along the River Bure to Stracey Arms Mill, near Acle, Norfolk Broads National Park

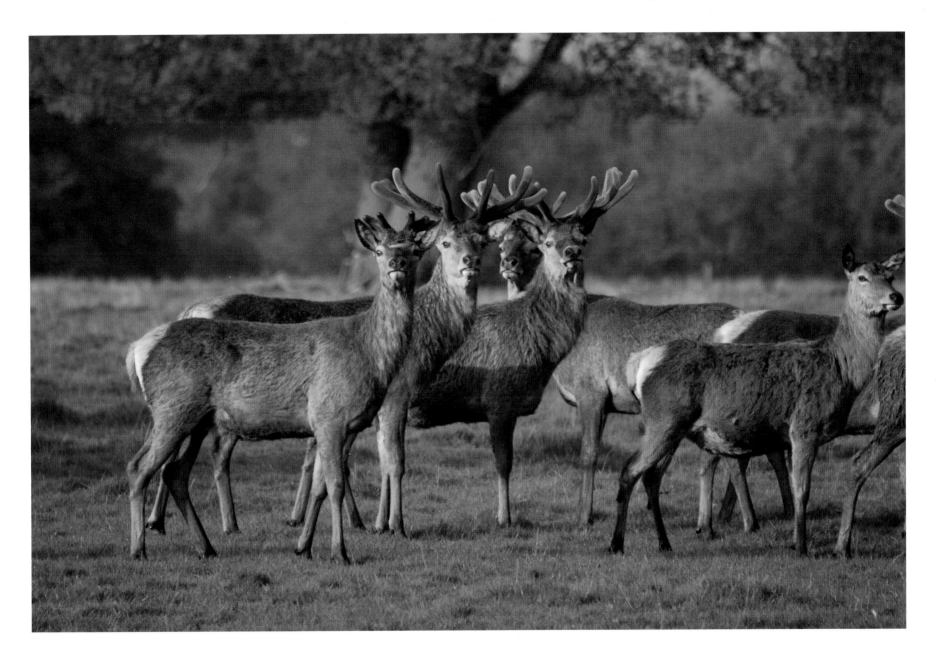

Deer in the grounds of Knebworth House, Hertfordshire

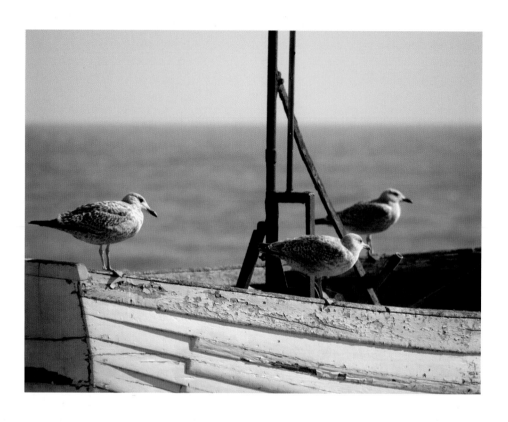

Seagulls on an old fishing boat at Aldeburgh, Suffolk

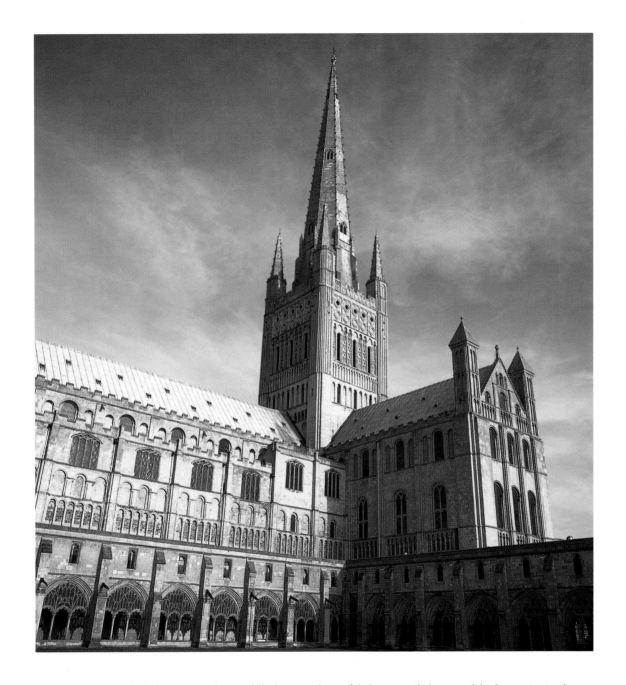

The great Norman cathedral in Norwich, Norfolk, boasts a beautiful cloister and the second highest spire in the country

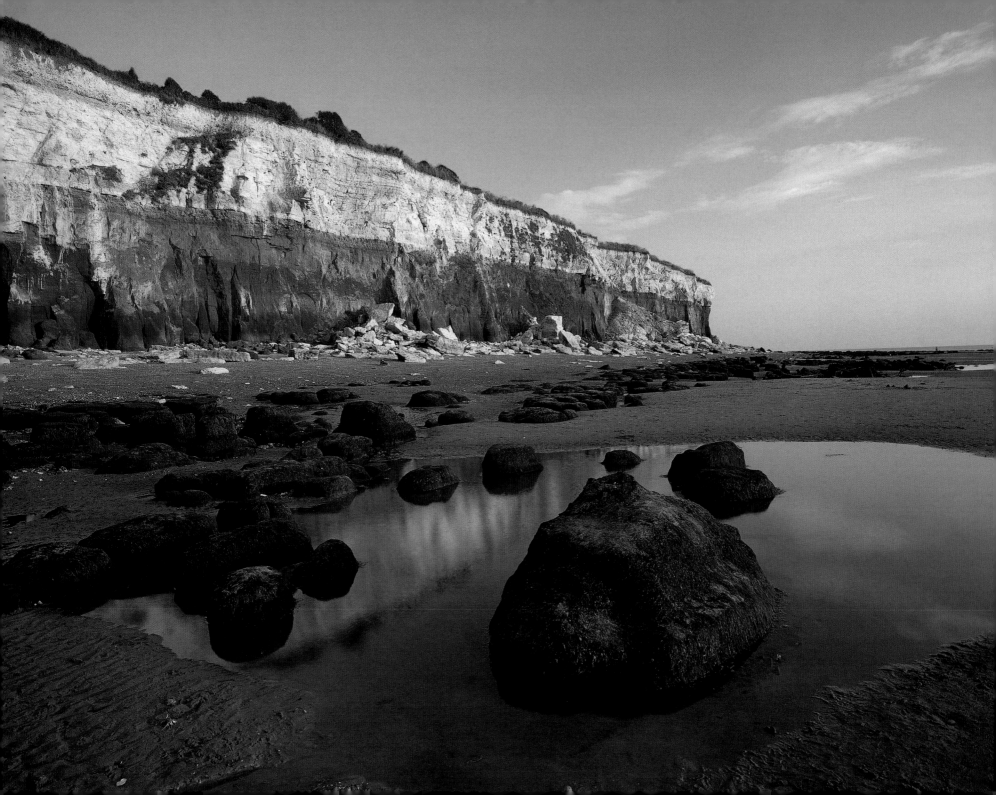

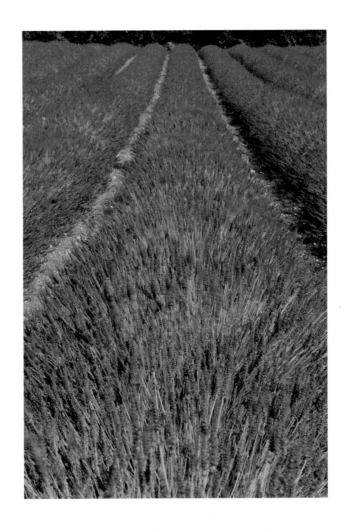

Fields of lavender at Heacham, Norfolk
Opposite: View of the cliffs at Hunstanton, Norfolk

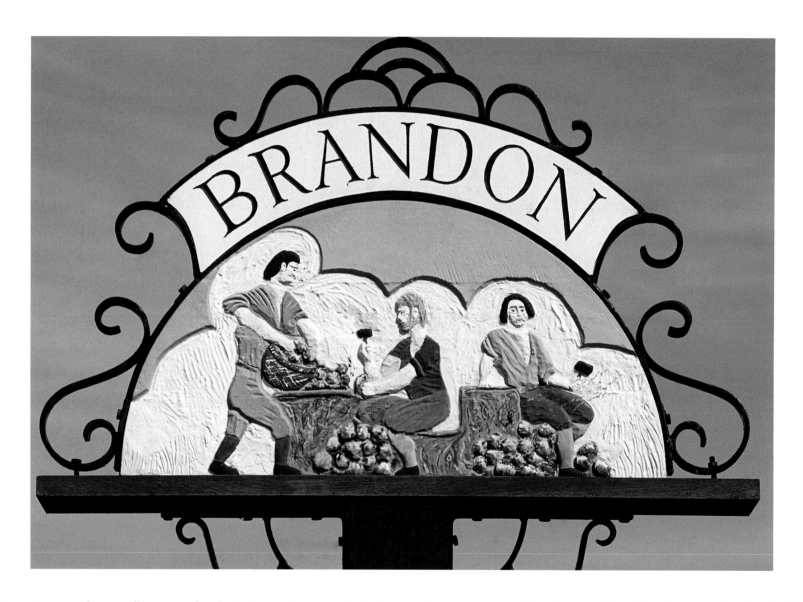

Decorative wrought iron village signs often depict historical events, a local industry, a character, or a legend linked to the village, like this sign at Brandon, Suffolk

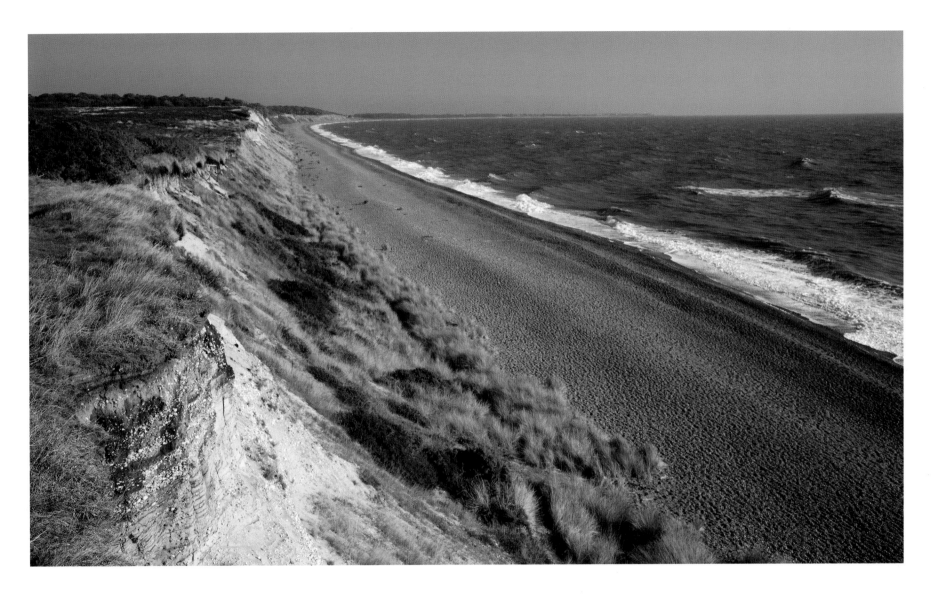

Looking along the sand cliffs and sweeping coastline towards Southwold at Dunwich, Suffolk

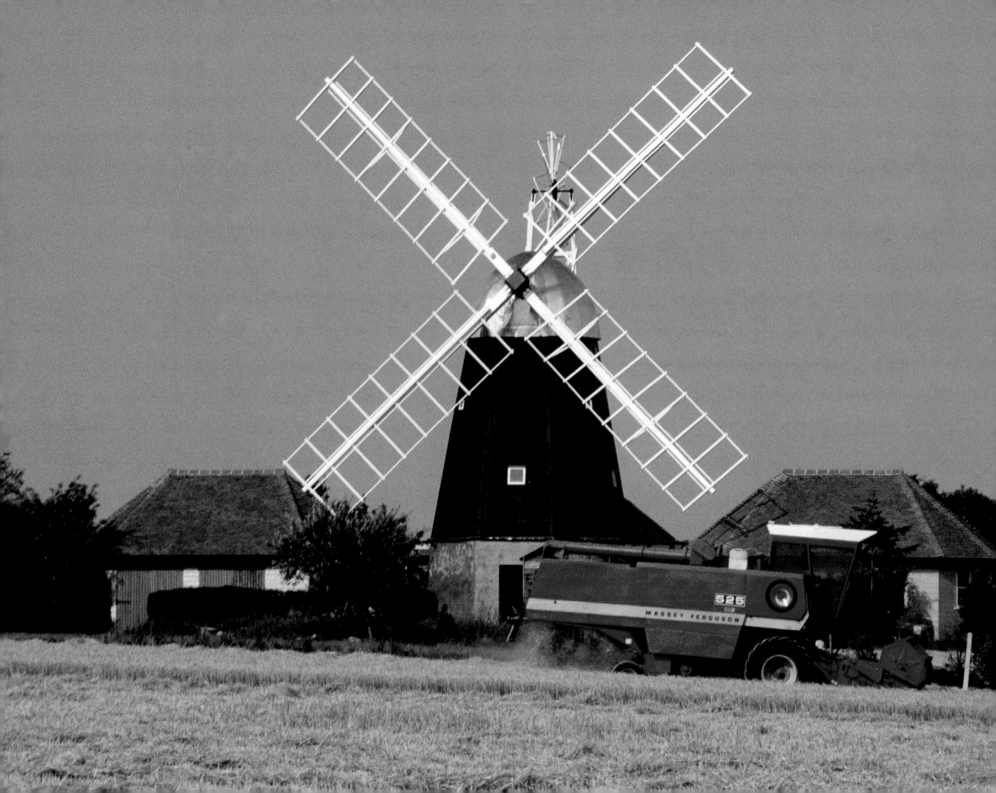

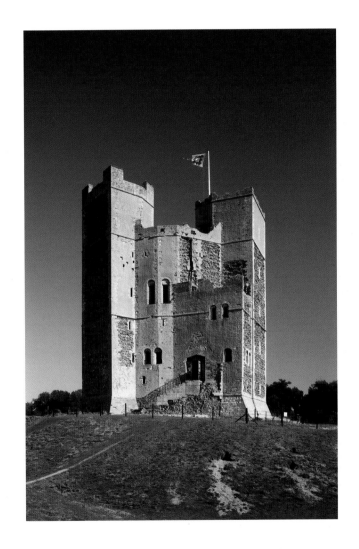

The 18-sided keep of Orford Castle, built in 1165 by Henry II, dominates Orford, Suffolk
Opposite: Harvest time at the 19th-century Smock Tower Mill at Swaffham Prior, Cambridgeshire

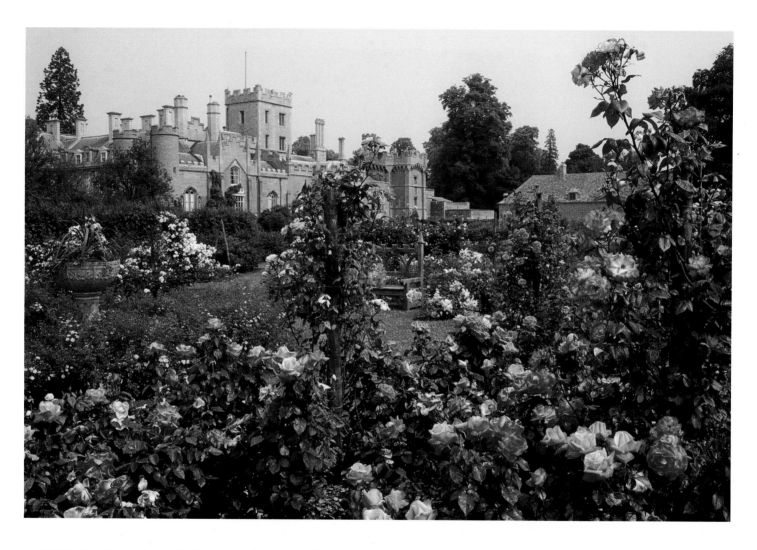

Old-fashioned roses frame the battlemented façade of Elton Hall, Cambridgeshire, a fine Gothic building dating from the 15th century

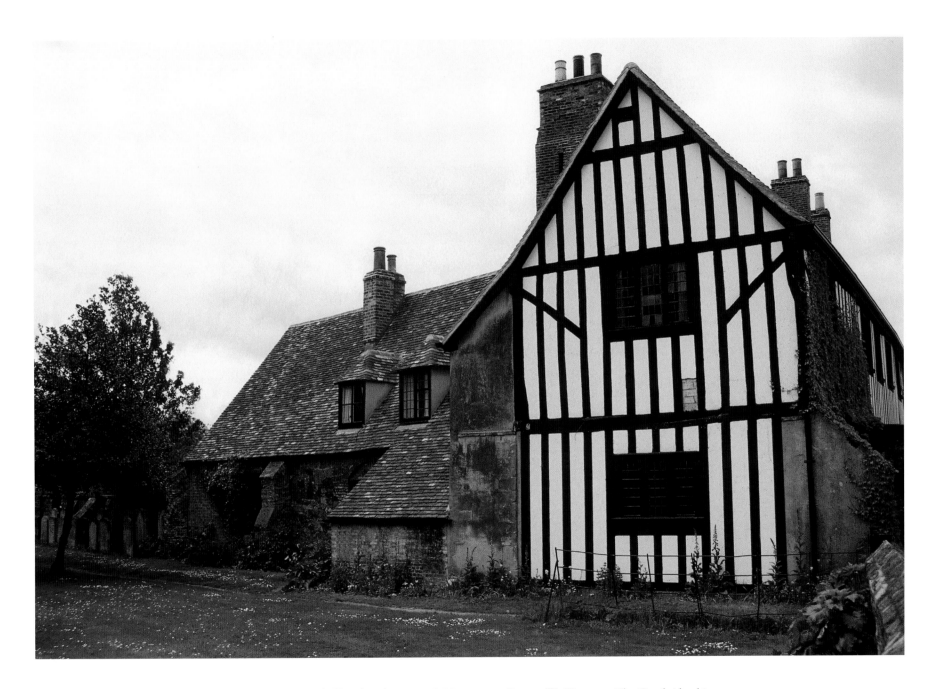

The 14th-century, half-timbered St Mary's Vicarage, or Cromwell's House at Ely, Cambridgeshire

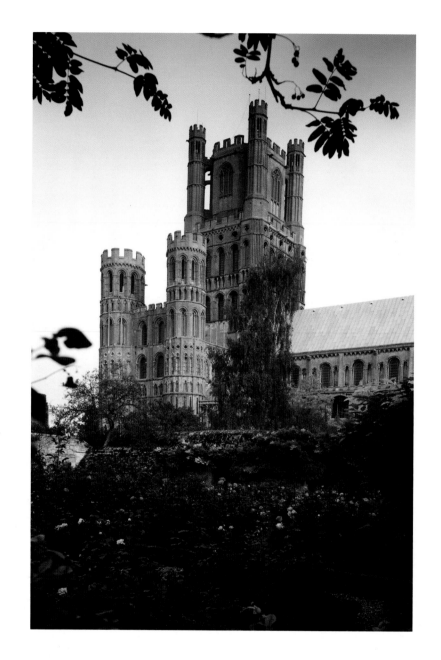

'Cathedral of the Fens', Ely, Cambridgeshire

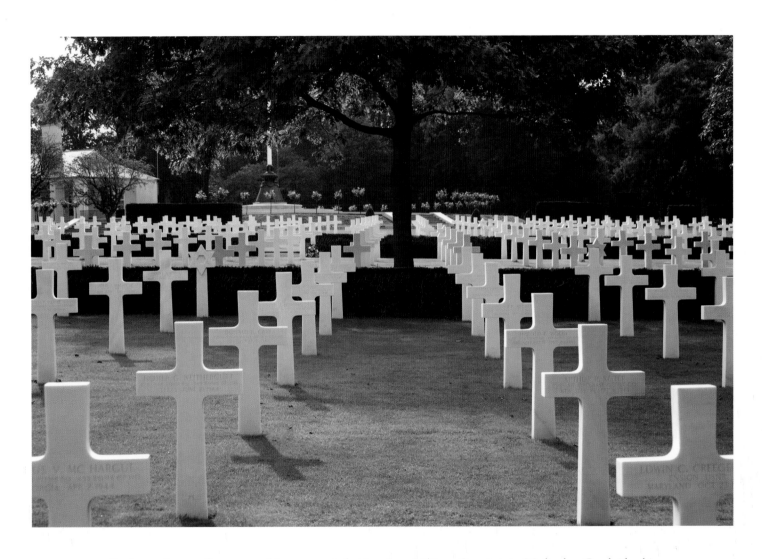

Regimented rows of crosses marking graves at the American Military Cemetery in Madingley, Cambridgeshire

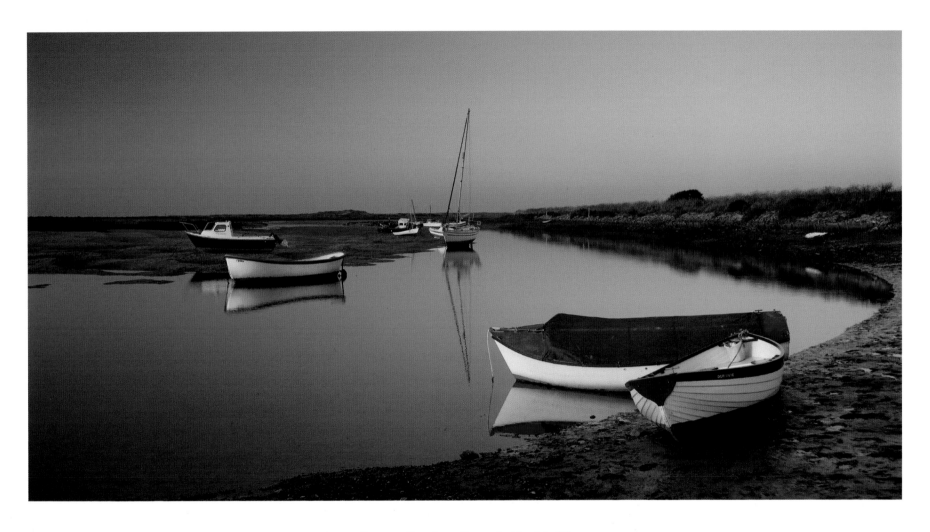

Boats at Burnham Overy Staithe, Norfolk
Opposite: Trees reflected in the lake at Wintergreen Wood, Knebworth, Hertfordshire

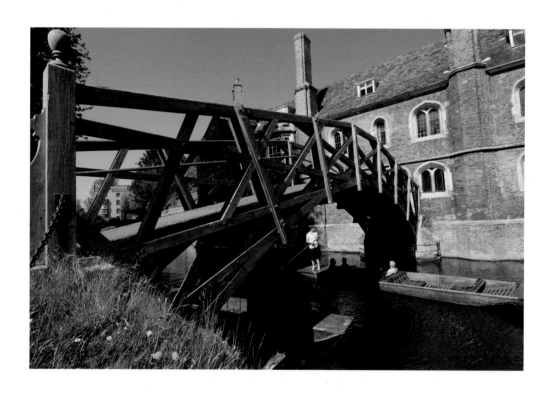

Built in 1749 the Mathematical Bridge accesses President's Lodge (1460), the oldest building on the River Cam in Cambridge, Cambridgeshire

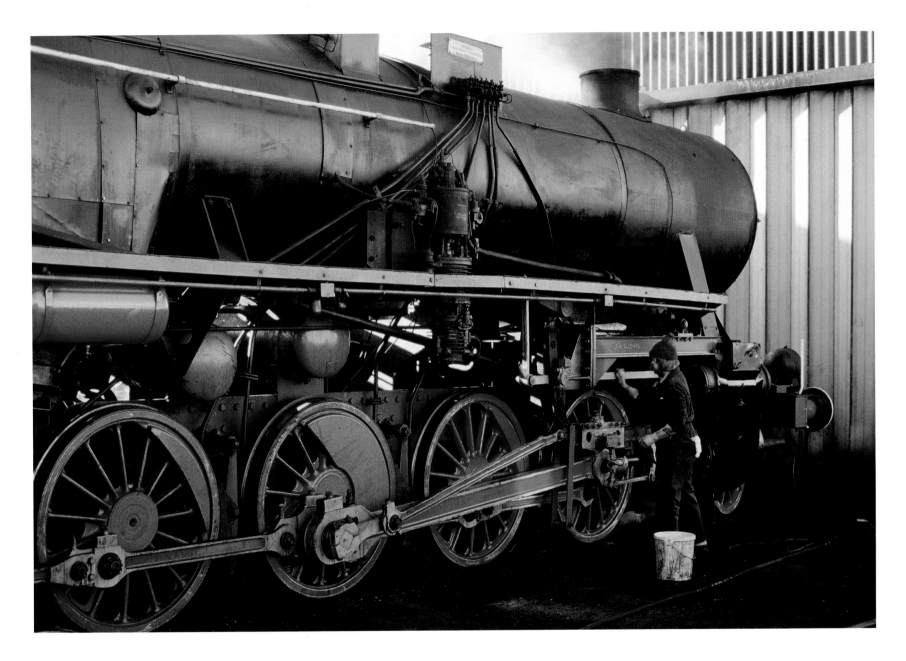

Maintenance of a steam train on the Nene Valley Railway, Cambridgeshire

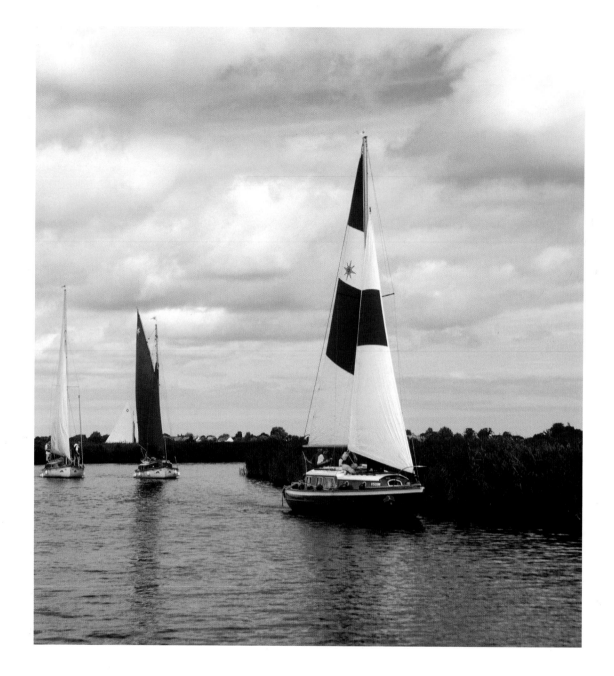

Sailing on the Broads in the Norfolk Broads National Park

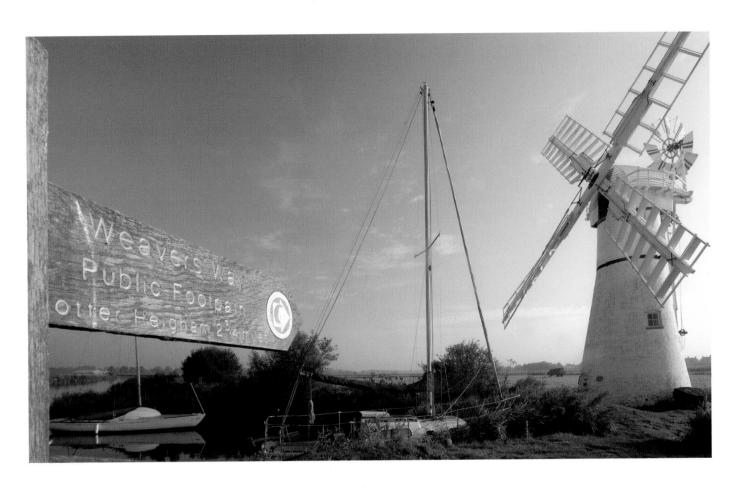

Timber-clad Thurne Mill stands on the Weavers' Way beside the River Thurne, Norfolk Broads National Park

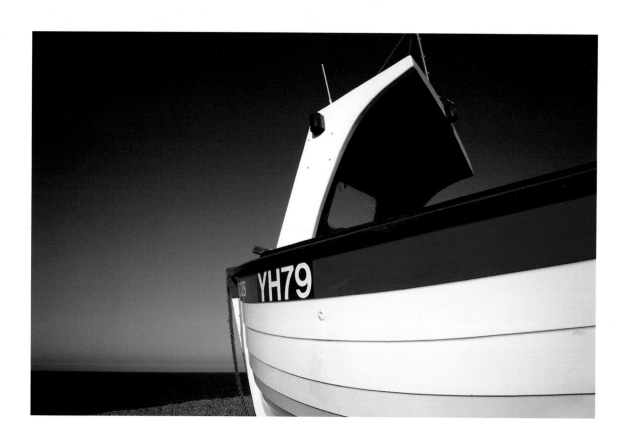

Fishing boat on Weybourne Beach, Norfolk

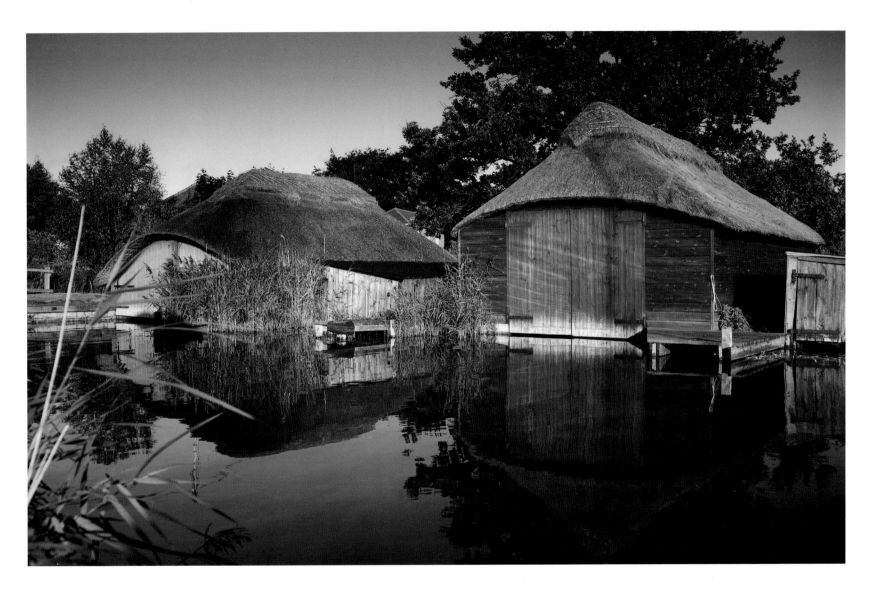

Thatched boathouses at Hickling Broad, Norfolk Broads National Park

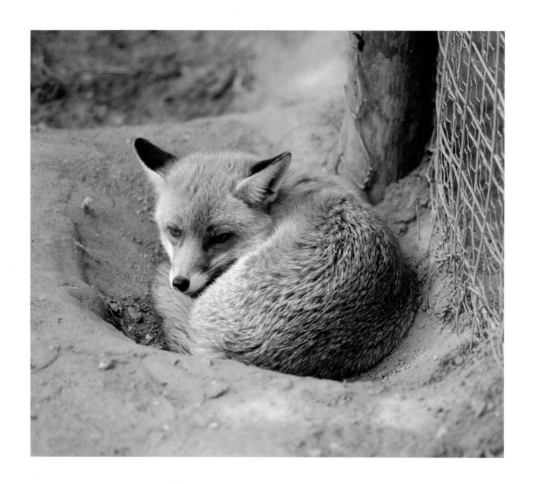

A red fox curled up in a cage at the Norfolk Wildlife Centre, Great Witchingham, Norfolk
Opposite: Rowing boat in the reed beds at Hickling Broad, Norfolk Broads National Park

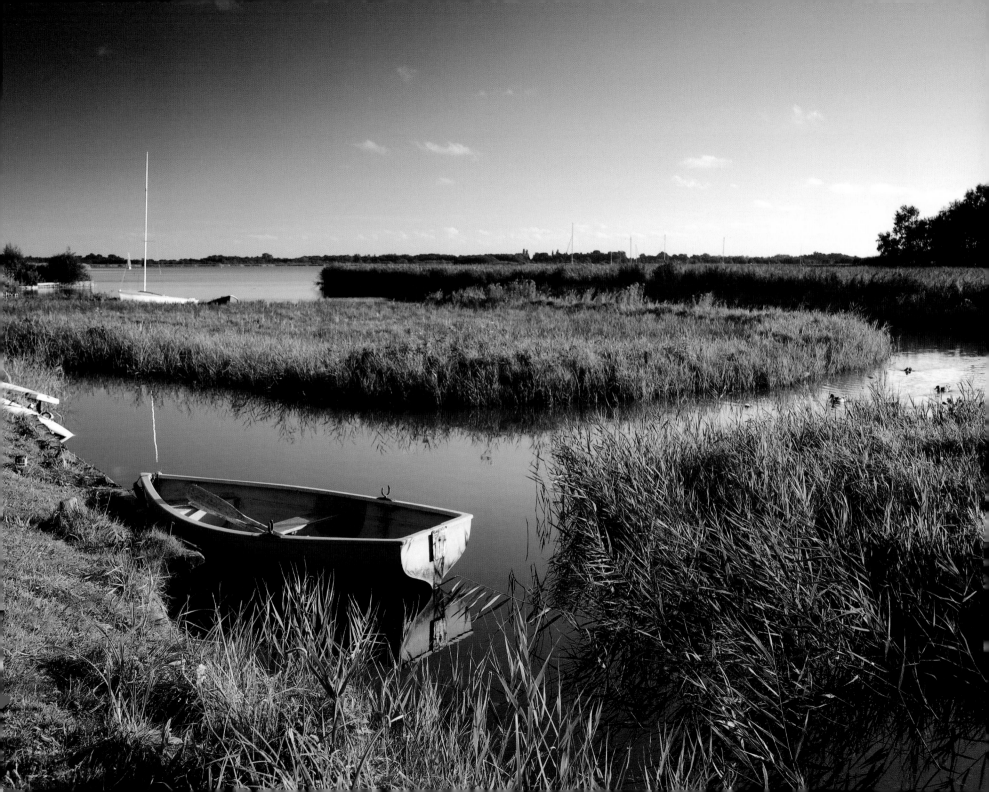

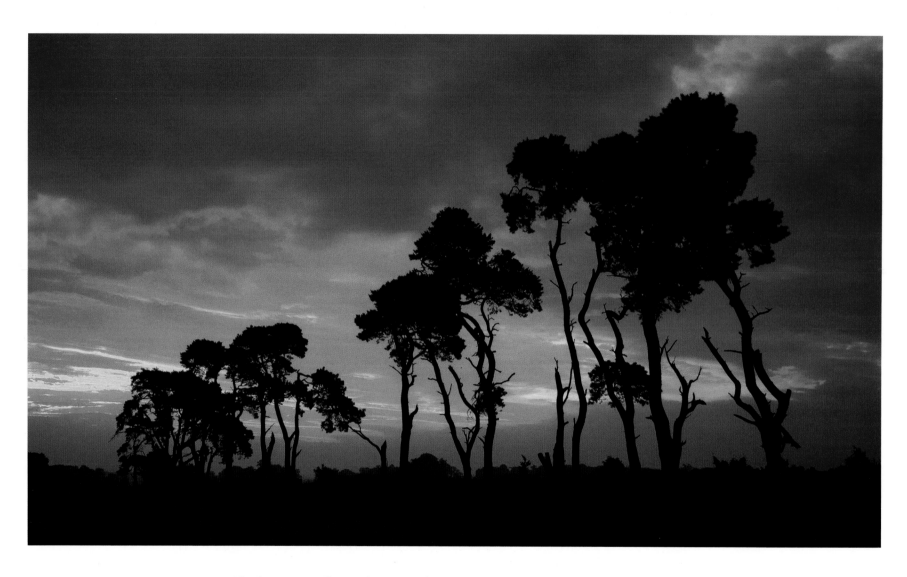

Breckland pine trees silhouetted against a dramatic red sky at sunrise in Thetford Forest, Norfolk

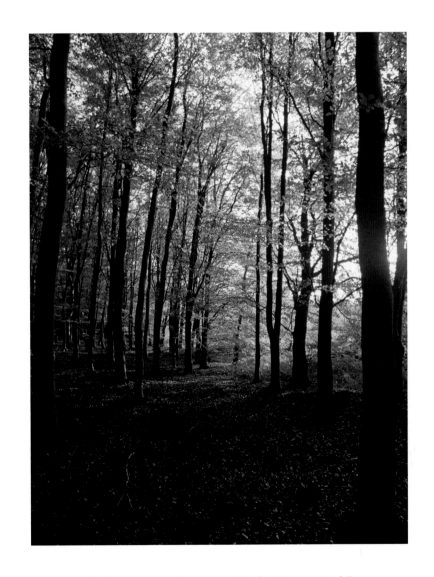

Looking through the trees at Thetford Forest, Norfolk

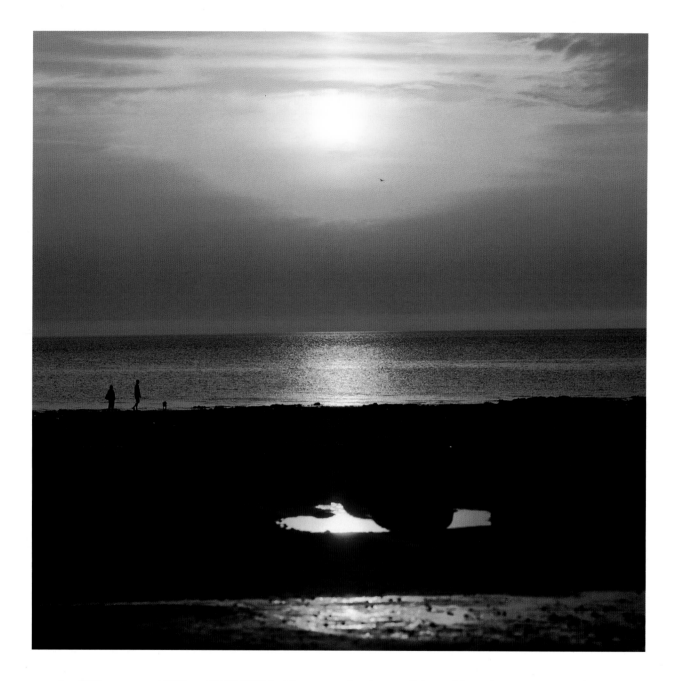

Walking along Hunstanton beach at sunset, Norfolk

86

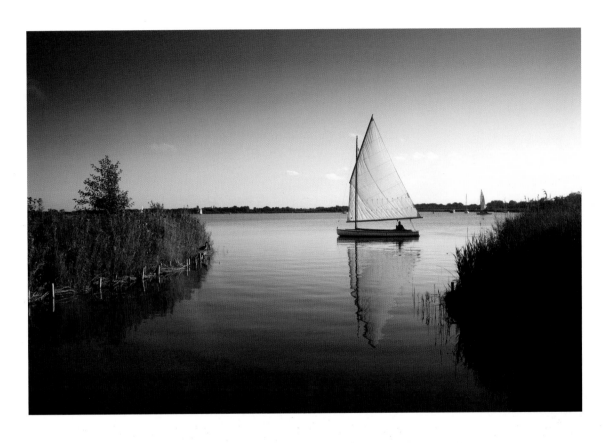

Sailing boat on Hickling Broad, Norfolk Broads National Park

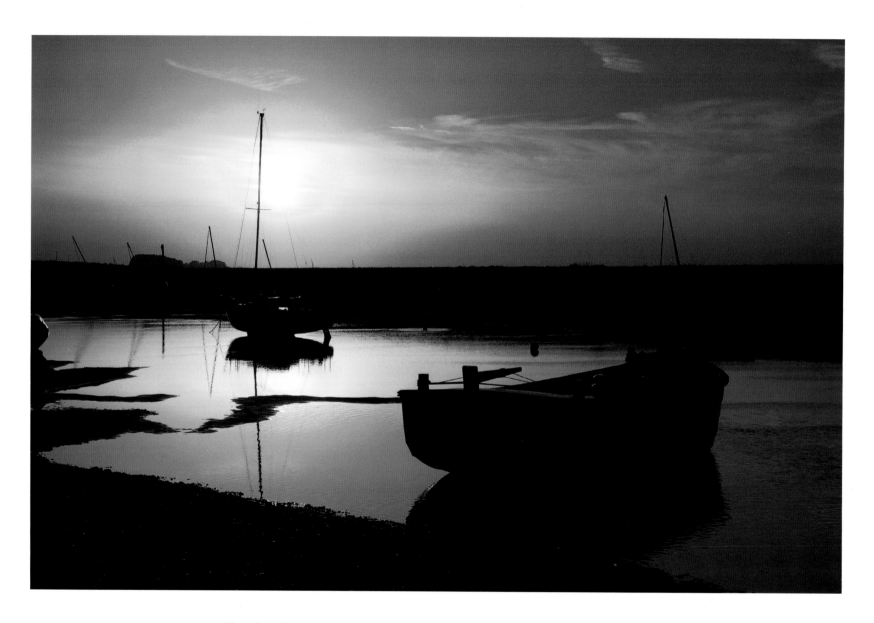

Sailboat bathed in the orange glow of the setting sun at Burnham Overy Staithe, Norfolk

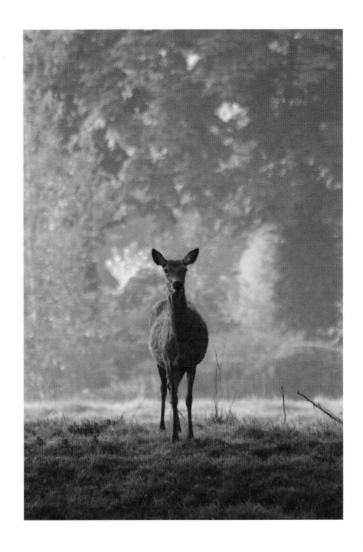

Deer in the grounds of Knebworth House, Hertfordshire

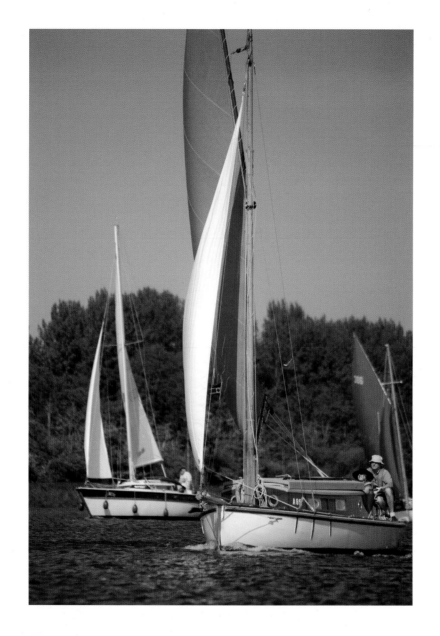

Colourful sailing boats on Barton Broad, Norfolk Broads National Park
Opposite: Eroded cliffs with Cromer Pier in the distance at West Runton, Norfolk

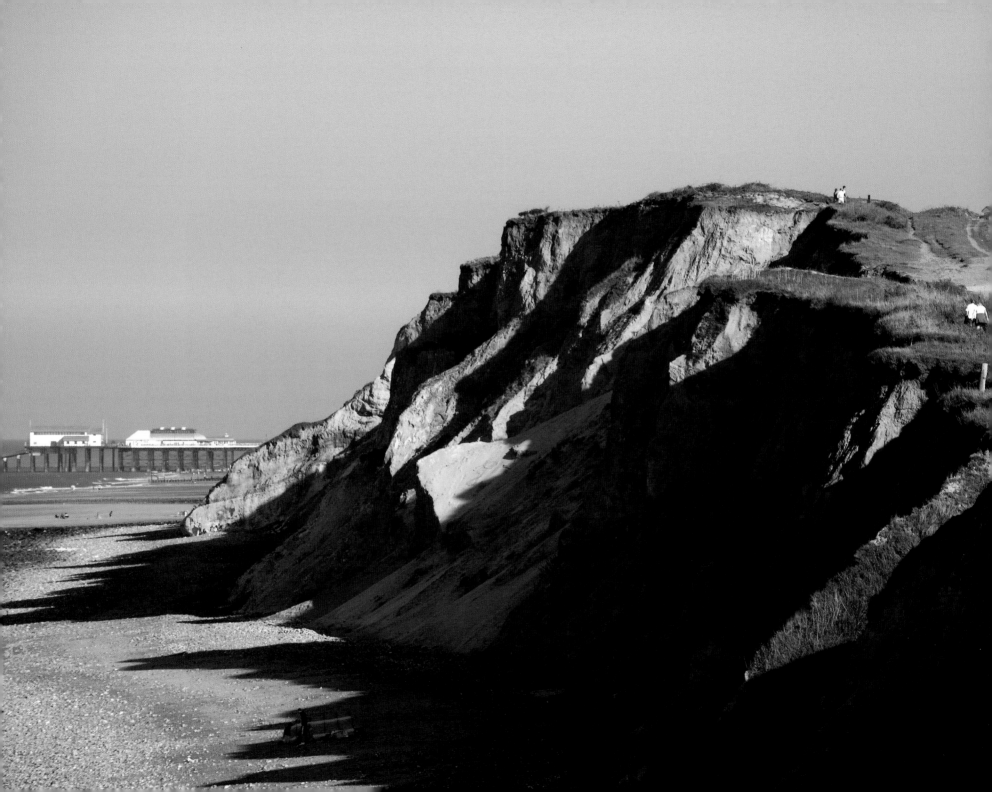

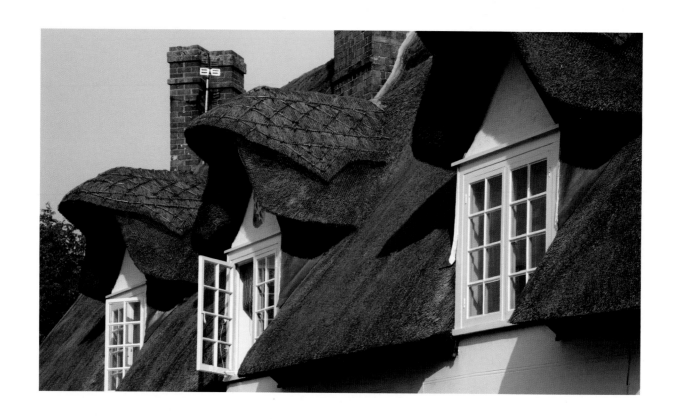

Windows peeping from beneath heavy thatch on a cottage in Madingley, Cambridgeshire

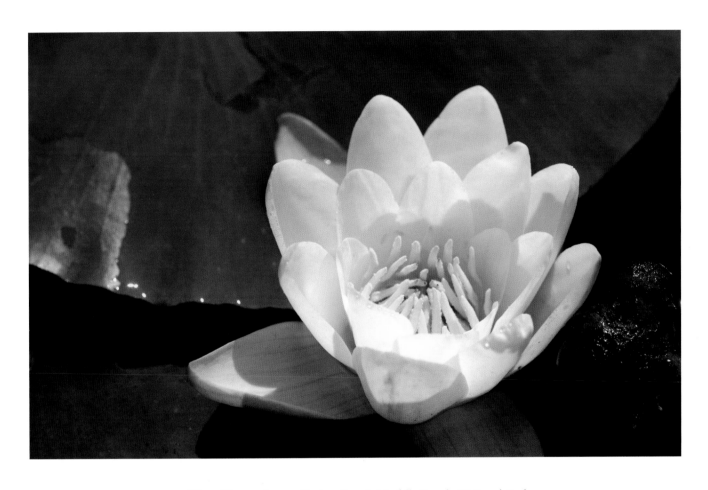

Water lily growing on Barton Broad, Norfolk Broads National Park

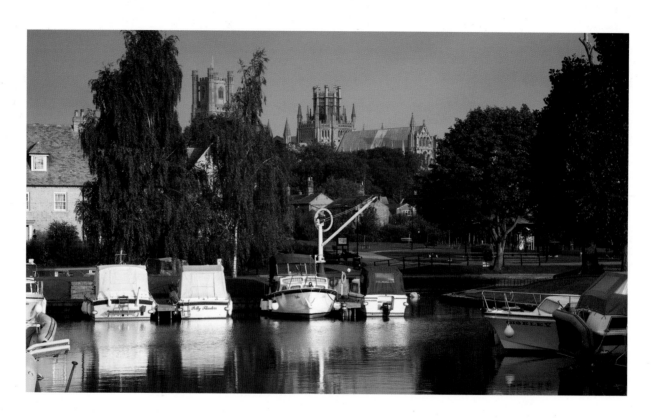

Ely Cathedral looms above the trees and the Great River Ouse at Ely, Cambridgeshire
Opposite: Looking up to the impressive, high-domed ceiling of Ely Cathedral, Cambridgeshire

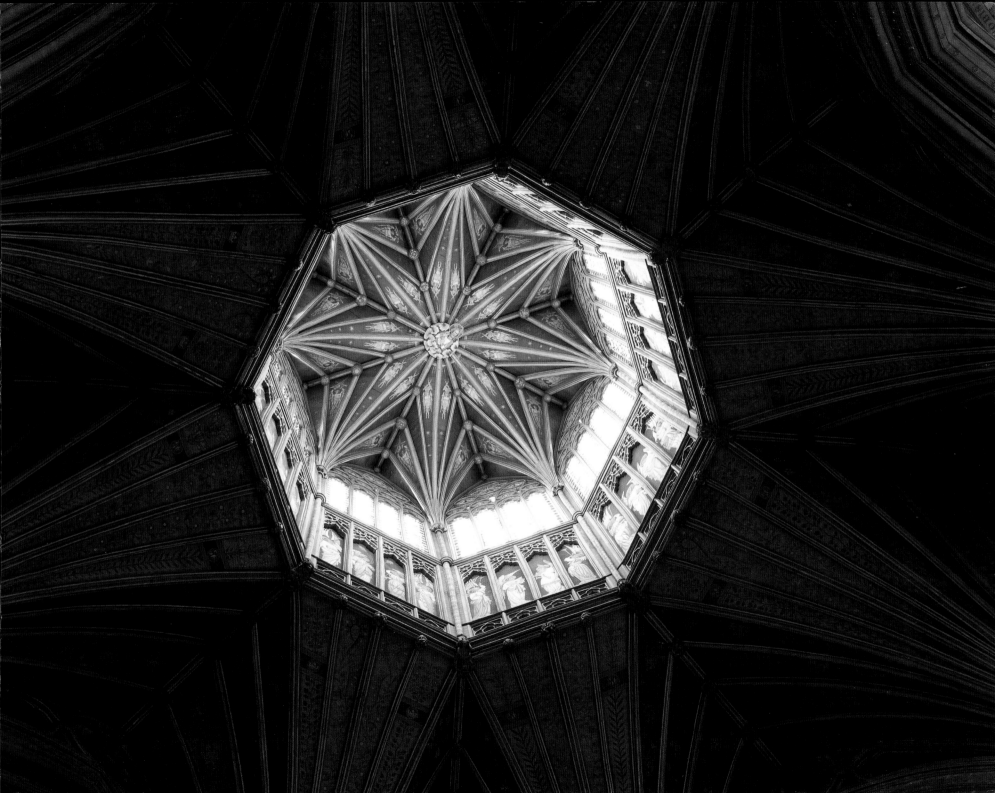

INDEX